The BIG BOOK of LOGOS 4

David E. Carter

COLLINS | DESIGN

An Imprint of HarperCollinsPublishers

THE BIG BOOK OF LOGOS 4
Copyright © 2006 by COLLINS DESIGN

HarperCollins books may be purchased for educational, business, or sales promotional use.
For information, please write: Special Markets Department, HarperCollins Publishers Inc.,
10 East 53rd Street, New York, NY 10022

First Paperback Edition

First published in hardcover in 2004 by:
Collins Design
An Imprint of HarperCollins*Publishers*
10 East 53rd Street
New York, NY 10022
Tel: (212) 207-7000
Fax: (212) 207-7654
collinsdesign@harpercollins.com
www.harpercollins.com

Distributed throughout the world by:
HarperCollins*Publishers*
10 East 53rd Street
New York, NY 10022
Fax: (212) 207-7654

Book Design by Designs by You!
Suzanna and Anthony Stephens

Library of Congress Control Number: 2004110152

ISBN-10: 0-06-089194-7
ISBN-13: 978-0-06-089194-7

Printed in China
First Paperback Printing, 2006

Number 4.

Three sequels now to the original *Big Book of Logos*.

Logo designers all over the world know the importance of keeping "in the loop," of having a source that shows the fresh new designs that are being produced by outstanding creative people.

The Big Book of Logos series IS that source.

The Big Book of Logos 4 is packed full of new designs that will inspire you, challenge you, and serve as a creative springboard.

For all those who create logos, this book will be your constant source for "solitary brainstorming."

1.

2.

3.

4.

5.

6.

7.

8.

4

We Build On Innovation.

9.

The MAXAlliance™

Trans*Action*™

10.

InsTrust™

INSURANCE GROUP

11.

G

GATES

INTERACTIVE

12.

SpaceSavers™

Self–Storage

A Paulk Company

13.

CONFERENCE
·2·0·0·2·

STI

14.

EARTH MATTERS™

Environmental Resource Collection

15.

MOUNTAIN HEALTH
CHIROPRACTIC & NEUROLOGY CENTER

1.

2.

3.

4.

CROSSROADS
WYOMING INITIATIVE FOR LIVING WITH DISABILITIES

5.

6.

orion pacific
plastics reprocessing

7.

8.

6

FIRST AMERICAN FUNDS™

ARCOLA MILLS

9.

10.

LANDMARK
C E N T E R

11.

12.

13.

amplatzer
MEDICAL

14.

15.

1 - 8
Design Firm **Catalyst Creative**
9 - 15
Design Firm **Larsen Design + Interactive**

1.
Client *Mountain Health Chiropractic*
Designer Jeanna Pool

2.
Client *Prufrock's Coffee*
Designer Jeanna Pool

3.
Client *Stoneworks Climbing Gym*
Designer Jeanna Pool

4.
Client *Update*
Designers Jeanna Pool, David Coleman

5.
Client *Wyoming Initiative for*
 Living with Disabilities
Designers Jeanna Pool, David Coleman

6.
Client *Phil's Natural Food Grocery*
Designer Jeanna Pool

7.
Client *Orion Pacific*
Designer Jeanna Pool

8.
Client *I-Proof*
Designers Jeanna Pool, David Coleman

9.
Client *First American Funds*
Designer Todd Nesser

10.
Client *Arcola Mills*
Designer Michelle Solie

11.
Client *Landmark Center*
Designer Bill Pflipsen

12.
Client *Tate Capital Partners*
Designer Bill Pflipsen

13.
Client *Target Corporation*
Designer Michelle Solie

14.
Client *AGA Medical Corporation*
Designer Michelle Solie

15.
Client *Target Corporation*
Designer Peter de Sibour

1.

2.

3.

4.

5.

6.

7.

8.

8

9.

10.

11.

12.

13.

FRIENDS FOR THE FIGHT

14.

15.

1 - 15
Design Firm **Bradford Lawton Design Group**

1.
Client — *New Heights Methodist Church*
Designer — Jody Laney

2.
Client — *True Slate*
Designers — Bradford Lawton, Jody Laney

3.
Client — *KPAC Texas Public Radio*
Designers — Jody Laney, Bradford Lawton

4.
Client — *Marriage and Family Counseling*
Designer — Bradford Lawton

5.
Client — *Rick Smith Dog Training*
Designer — Jody Laney

6.
Client — *Sav-A-Baby*
Designers — Becky Haas, Bradford Lawton

7.
Client — *Gary Pools*
Designers — Becky Haas, Bradford Lawton

8.
Client — *Lone Star Overnight*
Designer — Bradford Lawton

9.
Client — *Alamo Heights Pool*
Designers — Jody Laney, Bradford Lawton

10.
Client — *Family Violence Prevention Service*
Designer — Jody Laney

11.
Client — *University Physicians Group*
Designers — Bradford Lawton, Jody Laney

12.
Client — *Texas Diabetes Institute*
Designer — Bradford Lawton

13.
Client — *Air Force Federal Credit Union*
Designer — Jennifer Zinsmeyer Murillo

14.
Client — *Friends for the Fight*
Designer — Leslie Magee

15.
Client — *Wing Basket*
Designer — Jennifer Zinsmeyer Murillo

1.

2.

3.

4.

5.

TRIANGLE PROPERTIES

6.

7.

1 - 6
Design Firm **Guarino Graphics & Design Studio**

7
Design Firm **Monderer Design**

1.
Client *Carriage Barn Realty*
Designer Jan Guarino

2.
Client *Cradle of Aviation*
Designer Jan Guarino

3.
Client *DCI Communications*
Designer Jan Guarino

4.
Client *KASL Company LLC*
Designer Jan Guarino

5.
Client *MS Ballin*
Designer Jan Guarino

6.
Client *Triangle Properties*
Designer Jan Guarino

7.
Client *Lightbridge*
Designers Jason CK Miller,
 Stewart Monderer

(opposite)
Client *Flying Star Cafe*
Design Firm **Vaughn Wedeen Creative**
Designer Pamela Chang

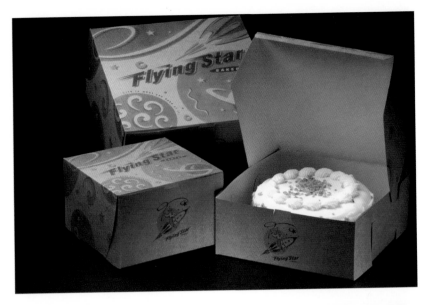

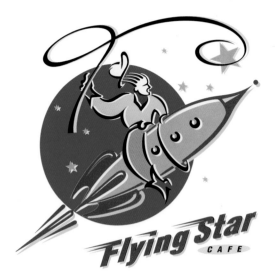

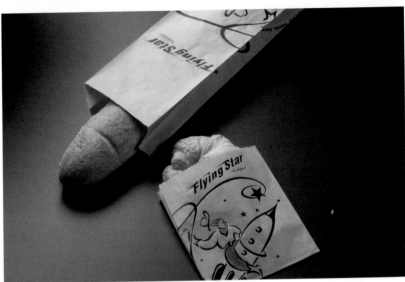

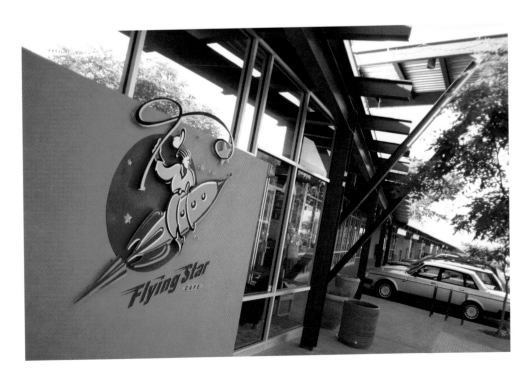

SPACE

1.

FLEMING

2.

3.

CREATIVE CLUB *of* SAN ANTONIO

4.

WINGS & CO.

5.

SAN ANTONIO RIVER FOUNDATION

6.

7.

The Birth Place
AT SOUTHWEST GENERAL HOSPITAL

8.

9.

10.

11.

12.

13.

cielos

14.

15.

1 - 15
Design Firm **Bradford Lawton Design Group**

1.
Client BBtt
Designer Bradford Lawton

2.
Client Fleming
Designer Bradford Lawton

3.
Client Easy Inch Loss Program
Designer Leslie Magee

4.
Client Creative Club of San Antonio
Designer Rolando M. Murillo

5.
Client Wings Basket
Designer Rolando M. Murillo

6.
Client San Antonio River Foundation
Designers Rolando M. Murillo, Bradford Lawton

7.
Client KSTX Texas Public Radio

8.
Client Southwest General Hospital
Designers Bradford Lawton, Jody Laney

9.
Client San Antonio Youth Literacy
Designer Jennifer Zinsmeyer Murillo

10.
Client Williams Landscaping
Designer Bradford Lawton

11.
Client Luna C Restaurant
Designers Bradford Lawton, Jody Laney

12.
Client San Antonio Botanical Society
Designer Bradford Lawton

13.
Client Creative Surgeons
Designers Bradford Lawton, Jody Laney

14.
Client Frontier Ent.
Designers Rolando Murillo, Bradford Lawton

15.
Client Gemini Ink
Designers Leslie Magee

5.

2.

7.

3.

1.

4.

6.

1
Design Firm **Wizards of the Coast**
2 - 4
Design Firm **Glitschka Studios**
5 - 7
Design Firm **End2End Integration, LLC**
1.
Designers Jeremy Cranford,
 Yasuyo Dunnett
2.
Client *Samurai Guppy*
Designer Von R. Glitschka
3.
Client *www.blogintosh.com*
Designer Von R. Glitschka
4.
Client *Handyman Solutions*
Designer Von R. Glitschka

5.
Client *My Novel Idea*
Designer Scott Wyss
6.
Client *Quick Design Signs*
Designer Scott Wyss
7.
Client *Party Campus*
Designer Scott Wyss
(opposite)
Client *Satellite Coffee*
Design Firm **Vaughn Wedeen Creative**
Designer Pamela Chang

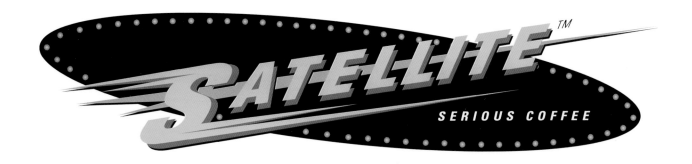

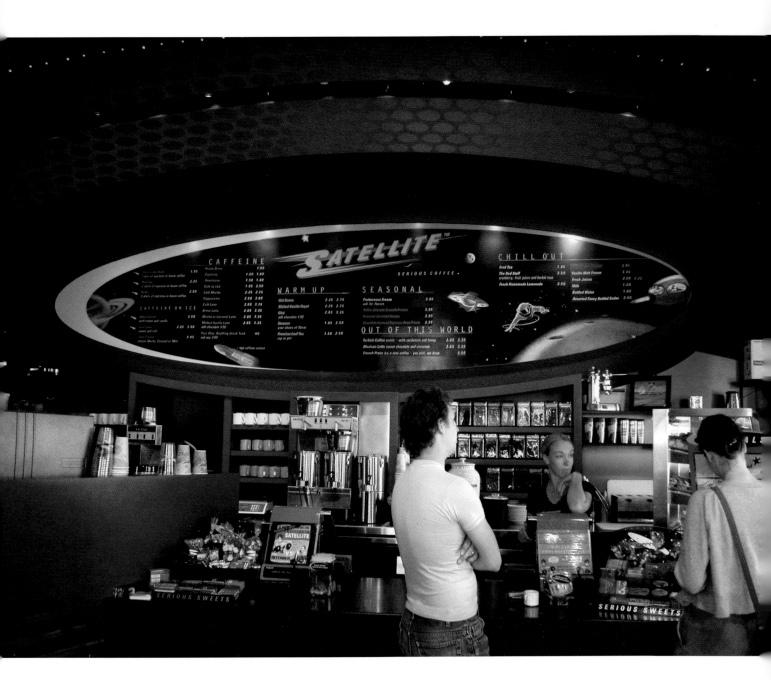

1.

2.

3.

MODRALL SPERLING
ROEHL HARRIS & SISK, P.A.

LAWYERS

4.

Amy Biehl

High School

5.

6.

7.

AGUAVIDA

8.

9.

10.

biosgroup
science for business

11.

DENISH + KLINE ASSOCIATES

12.

13.

National **Hispanic** Cultural Center

14.

15.

1, 2, 9, 10
Design Firm **Bradford Lawton Design Group**
3 - 8, 11 - 15
Design Firm **Vaughn Wedeen Creative**

1.
 Client *Texas Primate Observatory*
 Designer Bradford Lawton
2.
 Client *Railtex*
 Designers Bradford Lawton, Jody Laney
3.
 Client *Zocalo LLC*
 Designer Rick Vaughn
4.
 Client *Modrall Sperling Lawyers*
 Designer Pamela Chang
5.
 Client *Amy Biehl High School*
 Designers Steve Wedeen, Pamela Chang
6.
 Client *nCube*
 Designer Pamela Chang
7.
 Client *Academy Printers*
 Designer Pamela Chang

8.
 Client *AguaVida*
 Designer Pamela Chang
9.
 Client *Premier Catering*
 Designers Bradford Lawton, Jody Laney
10.
 Client *Wildlife Rescue & Rehabilitation*
 Designer Rolando Murillo
11.
 Client *BiosGroup*
 Designer Pamela Chang
12.
 Client *Denish + Kline Associates*
 Designer Pamela Chang
13.
 Client *Ansaldi Shaw Design/Architecture*
 Designer Steve Wedeen
14.
 Client *National Hispanic Cultural Center*
 Designers Steve Wedeen, Pamela Chang
15.
 Client *City of Albuquerque, New Mexico*
 Designer Rich Vaughn

CALIFORNIA HORSE PARK

A STATE OF THE ART EQUINE SHOW FACILITY

1.

total vein care

vein and aesthetic laser center

2.

Randi Wolf

D E S I G N

3.

Marc S. Cohen, MD, FACS • Nancy G. Swartz, MS, MD, FACS
Ophthalmic Plastic and Cosmetic Surgeons

4.

GALEÁNA
WOOD PRODUCTS

5.

GALEÁNA
WOOD PRODUCTS

6.

LITTLETON PUBLIC SCHOOLS FOUNDATION

If You Want Oak Trees, You Have To Plant Acorns

7.

1, 2
Design Firm **Market Street Marketing**
3, 4
Design Firm **Randi Wolf Design**
5 - 7
Design Firm **Hat Trick Creative, Inc.**
1.
Client *California Horse Park*
Designer Kathleen Downs
2.
Client *Total Vein Care*
Designer Kathleen Downs
3.
Client *Randi Wolf Design*
Designer Randi Wolf
4.
Client *Dr. Marc Cohen,*
 Dr. Nancy Swartz
Designer Randi Wolf

5, 6.
Client *Galeána Wood Products*
Designers Charlie Pate, Lance Brown
7.
Client *Littleton Public Schools*
 Foundation
Designers Lance Brown, Charlie Pate
(opposite)
Client *Albuquerque Isotopes*
Design Firm **Vaughn Wedeen Creative**
Designer Pamela Chang

Albuquerque

1.

ANJALI

Animal Humane Association
of New Mexico

2.

3.

4.

5.

6.

7.

8.

9.

10.

11.

12.

13.

ALTRAMED

14.

15.

1 - 3
Design Firm **Vaughn Wedeen Creative**
4 - 15
Design Firm **Ramp**

1.
 Client *Anjali Living Community Center*
 Designer Pamela Chang

2.
 Client *Animal Humane Association of New Mexico*
 Designer Pamela Chang

3.
 Client *Provident Realty*
 Designer Rich Vaughn

4.
 Client *Mark Stewart Securities*
 Designer Michael Stinson

5.
 Client *DirectColor*
 Designer Michael Stinson

6.
 Client *b&beyond*
 Designers Michael Stinson, Rachel Elnar

7.
 Client *Canon Development Americas*
 Designers Michael Stinson, Rachel Elnar

8.
 Client *Evans & Evans Construction Services*
 Designer Michael Stinson

9, 10.
 Client *Safety Syringes*
 Designer Michael Stinson

11.
 Client *Canon Development Americas*
 Designers Michael Stinson, Rachel Elnar

12.
 Client *Dave Perry*
 Designer Michael Stinson

13.
 Client *Mark Stewart Securities*
 Designer Michael Stinson

14.
 Client *Altramed*
 Designer Michael Stinson

15.
 Client *CompLife*
 Designer Michael Stinson

Kensington | GLASS ARTS | Incorporated

1.

2.

3.

TAIT
ENGINEERING

4.

WEDDINGS & EVENTS

5.

CAIRNS + ASSOCIATES

6.

7.

1
 Design Firm **Jill Tanenbaum**
 Graphic Design & Advertising
2, 3
 Design Firm **VanPelt Creative**
4
 Design Firm **Erisa Creative**
5, 6
 Design Firm **Ethan Ries Designs**
7
 Design Firm **Cairns + Associates**

1.
 Client *Kensington Glass Arts*
 Incorporated
 Designer Sue Sprinkle

2.
 Client *VanPelt Creative*
 Designer Chip VanPelt

3.
 Client *Safe Harbor Hospice*
 Designer Chip VanPelt
4.
 Client *Tait Engineering*
 Designer Erin May
5.
 Client *MOD Weddings & Events*
 Designer Ethan Ries
6.
 Client *Cairns + Associates*
 Designer Ethan Ries
7.
 Client *Vaseline Intensive Care Lotion*
 Designer Ethan Ries
(opposite)
 Client *Goldline Controls, Inc.*
 Design Firm **DynaPac Design Group**
 Designer Lee A. Aellig

AQUA LOGIC

Automation and Chlorination

THE LOGICAL SOLUTION FOR PURE SWIMMING PLEASURE

IMAGINE

changing the world

1.

BURNS
AND COMPANY
CONSULTING

2.

KADEAN

CONSTRUCTION COMPANY

3.

WEINBAUER & ASSOCIATES, INC.
Tax & Financial Services

4.

SAINT LOUIS
SOCCER CAMPS

5.

SAINT · LOUIS
SOCCER · CAMPS

6.

LIVE ANOTHER DAY

7.

Edward Jones
BOO AT THE ZOO

8.

24

9.

10.

11.

12.

GOLF DAY 2002

13.

14.

15.

1 - 13
Design Firm **Bright Rain Creative**

14, 15
Design Firm **Pixallure Design**

1.
Client *St Louis Young Presidents Organization*
Designer Matt Marino

2.
Client *Burns and Company Consulting*
Designer Kevin Hough

3.
Client *Kadean Construction Company*
Designer Matt Marino, Bill Rice

4.
Client *Weinbauer & Associates, Inc.*
Designer Matt Marino

5, 6.
Client *St. Louis Soccer Camps*
Designer Matt Marino

7.
Client *Saint Louis Zoo*
Designer Kevin Hough

8, 9.
Client *Saint Louis Zoo*
Designer Matt Marino

10, 11.
Client *Bright Rain Creative*
Designers Kevin Hough, Matt Marino

12.
Client *Bob Abrams Idea Company*
Designer Matt Marino

13.
Client *Clayco Construction Company*
Designer Kevin Hough

14.
Client *Triple 40*
Designer Steven Lutz`

15.
Client *St. Mary Catholic School*
Designer Terry Edeker

1.

2.

3.

4.

5.

6.

7.

1
Design Firm **inc3**
2
Design Firm **Studio Hill Design**
3, 4
Design Firm **Lomangino Studio Inc.**
5
Design Firm **Merck Worldwide**
6
Design Firm **Atomic Design**
7
Design Firm **Robert Talarczyk Design**

1.
Client *Focus Integrated Fitness*
Designers Harvey Appelbaum,
 John Sexton,
 Christopher Nystrom
2.
Client *Milestone Imports*
Designers Sandy Hill,
 Sean Michael Chavez

3.
Client *Foster/Searing*
Designer Kim Pollock
4.
Client *H2 Land Company*
Designer Michael Mateos
5.
Client *Zocor hps*
Designer Robert Talarczyk
6.
Client *Auburn*
Designer Lewis Glaser
7.
Client *Robert Talarczyk Design*
Designer *Robert Talarczyk*
(opposite)
Client *Auto Care Products, Inc.*
Design Firm **DynaPac Design Group**
Designer Lee A. Aellig

26

1.

2.

3.

4.

5.

6.

7.

8.

GENESIS
Family Enterprises Inc.

9.

LODI
WINE COUNTRY

10.

MAMBO
Marketing With A Twist!

11.

G. ELLIS & CO.
COMMERCIAL REAL ESTATE

12.

NuCal Foods Inc.
Eggs can't get any fresher.

13.

NRC INC.
INSURANCE AGENCY

14.

AGILE OAK ORTHOPEDICS

15.

1 - 4
Design Firm **Bright Rain Creative**
5 - 15
Design Firm **Marcia Herrmann Design**

1, 2.
Client *Scrubs & Beyond*
Designers Kevin Hough, Matt Marino

3, 4.
Client *Scrubs & Beyond*
Designer Matt Marino

5.
Client *Meitetso Corporation*
Designer Marcia Herrmann

6.
Client *St. Lukes Family Practice*
Designer Marcia Herrmann

7.
Client *Patch Crew*
Designer Marcia Herrmann

8.
Client *Archworks*
Designer Marcia Herrmann

9.
Client *Genesis Family Enterprises*
Designer Marcia Herrmann

10.
Client *Lodi Wine Country*
Designer Marcia Herrmann

11.
Client *Mambo*
Designer Marcia Herrmann

12.
Client *G. Ellis & Co.*
Designer Marcia Herrmann

13.
Client *NuCal Eggs*
Designer Marcia Herrmann

14.
Client *NRC Insurance Agency Inc.*
Designers Marcia Herrmann,
 Sylvia Magdelana

15.
Client *Agile Oak Orthopedics*
Designer Marcia Herrmann

1.

T H E K E E N E Y E

2.

K I N A
D E S I G N

3.

Maverick
WINE COMPANY

4.

X E N O N
CAPITAL MANAGEMENT

5.

TJWALKER +
ASSOCIATES INC

6.

norman
A DESIGN STUDIO

7.

1
Design Firm **Lahn Nguyen**
2 - 7
Design Firm **Norman Design**
1.
Client *INKD Clothing*
Designer Lahn Nguyen
2.
Client *The Keen Eye*
Designer Claudia Renzi
3.
Client *Kina Design*
Designer Armin Vit
4.
Client *Maverick Wine Company*
Designer Armin Vit
5.
Client *Xenon Capital Management*
Designer Armin Vit

6.
Client *TJ Walker & Associates Inc.*
Designer Armin Vit
7.
Client *Norman Design*
Designer Armin Vit
(opposite)
Client *Putt Meister, Inc.*
Design Firm **DynaPac Design Group**
Designer Lee A. Aellig

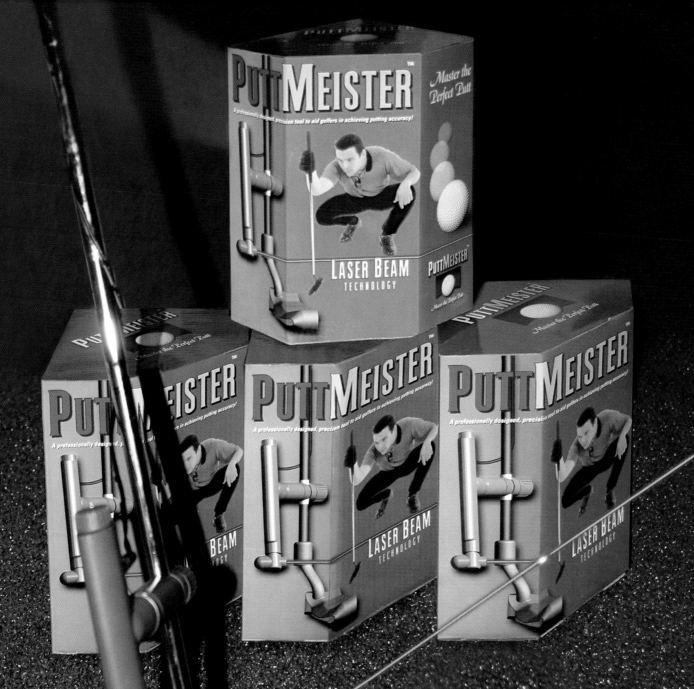

stop.
International for Spa

1.

Swadden Virgin & Young

2.

WILDEN LOFTS

3.

HEALTH POINT

The new model
of Primary Care

4.

MERCEDES
OLIVE

5.

MARIA MANNA LIFE SPA

6.

MAPLE LEAF
GIFT STORES

7.

2020
DOWNTOWN VICTORIA
2020

8.

9.

10.

11.

Glazin Sisco *executive search*

12.

GREATER
VICTORIA HOSPITALS
FOUNDATION

13.

14.

15.

1 - 15
Design Firm **Trapeze Communications**
1.
Client Stop. Hand & Foot Spa
Designer Mark Bawden
2.
Client Swadden, Virgin & Young
Designer Mark Bawden
3.
Client Wilden Lofts
Designer Mark Bawden
4.
Client Vancouver Island
 Health Authority
Designer Mark Bawden
5.
Client Mercedes Olive
Designers Mark Bawden, Joe Hedges
6.
Client Maria Manna
Designer Neil Tran
7.
Client Maple Leaf Gifts
Designer Joe Hedges

8.
Client Downtown Victoria 2020
Designer Marianne Unger
9.
Client Art Gallery of Greater Victoria
Designers Mark Bawden, June Paulovich
10.
Client Camosun College
Designer Mark Bawden
11.
Client Freshwater Fisheries Society
 of British Columbia
Designer Joe Hedges
12.
Client Glazin Sisco
Designers Mark Bawden, Marianne Unger
13.
Client Greater Victoria
 Hospitals Foundation
Designers Mark Bawden, Marianne Unger
14.
Client Grant Thornton
Designer Neil Tran
15.
Client Inspectech
Designers Mark Bawden, June Paulovich

1.

2.

KETTERING

3. TOWER

4.

5.

6.

7.

1 - 4
Design Firm **Nova Creative Group**

5
Design Firm **Grafik Marketing Communications**

6
Design Firm **Rutgers University**

7
Design Firm **Fleming & Roskelly, Inc.**

1.
Client *Dayton Philharmonic Orchestra*
Designer Dwayne Swormstedt

2.
Client *Wilmington Iron & Metal*
Designer Jack Denlinger

3.
Client *Miller Valentine*
Designer Jack Denlinger

4.
Client *Sinclair Community College Foundation*
Designers Dwayne Swormstedt, Ben Robinson

5.
Client *Market Salamander*
Designers Michelle Mar, Judy Kirpich, Heath Dwiggins

6.
Client *Food Innovation Research and Extension Center*
Designer John Van Cleaf

7.
Client *Adams Headwear*
Designers Tom Roskelly, Deb Moniz
(opposite)
Client *Mexotic Foods*
Design Firm **DynaPac Design Group**
Designer Lee A. Aellig

NEW

Includes Gourmet Sauce Tub & Cheese Packet for Added **"MEXCITING™"** Flavor

AMERICA'S FINEST
GOURMET
MEXOTIC™
CUISINE
PREMIUM FOODS

LOADED with **"MEXCEPTIONAL™"** QUALITY!

▼

FINEST INGREDIENTS and **MASTERFUL TECHNIQUE** CREATES SMOOTH, SUPERIOR TASTE!

▼

Previously Handled Frozen For Your Protection, Refreeze Or Keep Refrigerated

All Individually Sealed

FULLY COOKED • JUST HEAT & SERVE • READY IN ④ MINUTES

READY-TO-EAT
BEEF ESPECIAL

2 *Premium Beef Wraps* with *Gourmet Red Chili Sauce and Cheese*

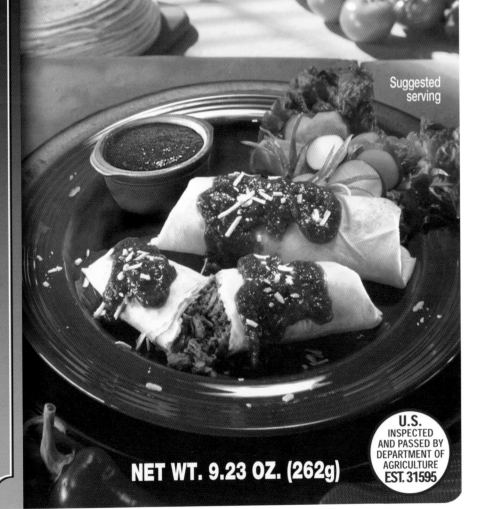

Suggested serving

NET WT. 9.23 OZ. (262g)

U.S. INSPECTED AND PASSED BY DEPARTMENT OF AGRICULTURE EST. 31595

35

Read Learning Centre

1.

QV

QUEEN VICTORIA HOTEL AND SUITES

2.

3.

VICTORIA CONFERENCE CENTRE

4.

VICTORIA FOUNDATION

5.

SIBA CORP

6.

Milbank PROJECTS PLUS FALL ISSUE

7.

Professor Proxy™

8.

9.

JS Public Relations

10.

11.

Cantor **SEINUK**
STRUCTURAL ENGINEERS

12.

CDR
Credit Derivatives Research LLC

13.

Gimme Credit™

14.

15.

1 - 5
Design Firm **Trapeze Communications**
6 - 15
Design Firm **Rappy & Company**

1.
Client *Victoria Read Society*
Designers Mark Bawden, Marianne Unger

2 - 3.
Client *Queen Victoria Inn*
Designers Mark Bawden, Joe Hedges

4.
Client *Victoria Conference Centre*
Designers Mark Bawden, Chris Paul

5.
Client *Victoria Foundation*
Designers Joe Hedges, Mark Bawden

6.
Client *SIBA Corp.*
Designers Floyd Rappy, Nicole Picarillo

7.
Client *Milbank*
Designers Floyd Rappy, Brian Santiago

8.
Client *Mediant Communications*
Designers Floyd Rappy, Amanda Skudlarek

9.
Client *Mediant Communications*
Designers Floyd Rappy, Jamie Flohr

10.
Client *JS Public Relations*
Designer Floyd Rappy

11.
Client *Go Go Gomez*
Designers Floyd Rappy, Kristina Schmidt

12.
Client *Cantor Seinuk*
Designers Floyd Rappy, Mary Smith

13.
Client *Credit Derivatives Research LLC*
Designers Floyd Rappy, Brian Jones,
Kristina Schmidt

14.
Client *Gimme Credit*
Designers Floyd Rappy, Soohyen Park

15.
Client *Girl Scouts of the USA*
Designer Floyd Rappy

industrial modeling corporation

1.

2.

3.

UNIVERSITY SQUARE

4.

Johnson & Johnson
Wound Management
A division of ETHICON, INC.

5.

6.

LIFE & HEALTH *of* AMERICA®

7.

1
Design Firm **DrrtyGrrl Designs**
2, 3
Design Firm **JenGraph**
4 - 7
Design Firm **The Bailey Group**
1.
Client *Industrial Modeling Corporation*
Designer Debbi Murray
2.
Client *Guentherman Consulting, Inc.*
Designer Jennifer A. Niles
3.
Client *Jennifer Rebecca Designs*
Designer Jennifer A. Niles
4.
Client *University of Pennsylvania*
Designers Jerry Corcoran, Steve Perry,
 Dave Fiedler

5.
Client *Ethicon*
Designers Steve Perry, Wendy Slavish,
 Lizzy Lee
6.
Client *Ethicon*
Designer Ann marie Malone
7.
Client *Life & Health of America*
Designers Dave Fiedler, Jerry Corcoran
(opposite)
Client *Nestle Chocolates*
Design Firm **TD2, S.C.**
Designers Rafael Rodrigo Córdova,
 Rafael Treviño M.

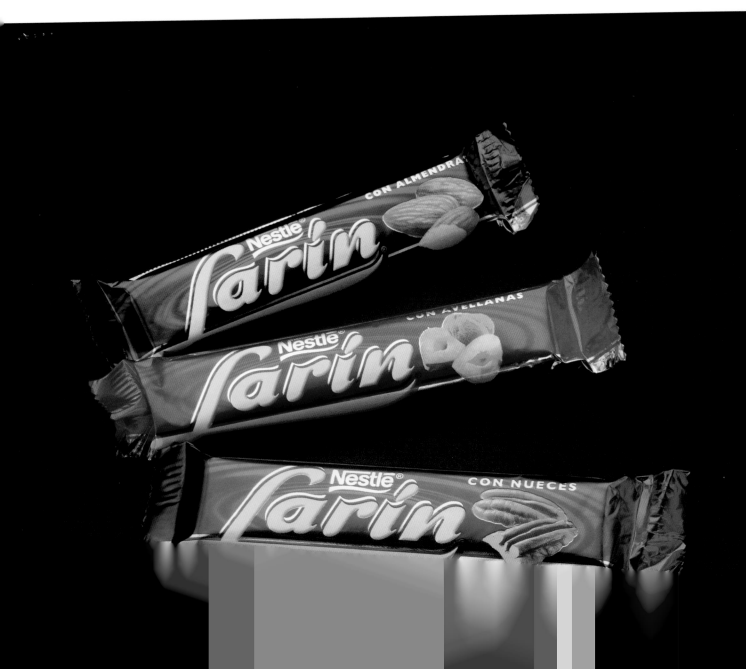

1.

**Check Yearly.
See Clearly.**SM

2.

3.

netpark pride
Celebrating Teamwork

4.

5.

alzheimer's association
memory walk '04

6.

7.

8.

40

9.

10.

11.

12.

13.

BREWER & TOMINAGA

14.

15.

1 - 8
Design Firm **Porter Novelli**
9 - 15
Design Firm **Mark Deitch & Assoc., Inc.**

1.
Client *DUDA*
Designer Todd Metrokin

2.
Client *Vision Council of America*
Designers Penny Rigler, Peter Buttecali

3.
Client *Washington DC Baseball*
Designers Rebecca Mabie, Matt Stevenson

4.
Client *Medco*
Designers Todd Metrokin, Penny Rigler

5.
Client *Fresh Produce Association of the Americas*
Designer Todd Metrokin

6.
Client *Alzheimer's Association*
Designers Todd Metrokin, Allyson Hummel

7.
Client *American Forest & Paper Association*
Designers Todd Metrokin, Mike Gallagher, Penny Rigler

8.
Client *Food Forum 3000*
Designer Penny Rigler

9.
Client *Evolution Music Partners*
Designer Dvorjac Riemersma

10.
Client *AEG*
Designer Lisa Clark

11.
Client *Latin Academy of Recording Arts & Sciences*
Designer Lisa Clark

12.
Client *Center for Improvement of Child Caring*
Designer Dvorjac Riemersma

13.
Client *Mackworks*
Designer Dvorjac Riemersma

14.
Client *Brewer & Tominaga*
Designer Dvorjac Riemersma

15.
Client *VEDA*
Designer Dvorjac Riemersma

1.

Ojo Photography

2.

3.

4.

5.

6.

peace through pride

7.

1
Design Firm **Proximity Canada**
2
Design Firm **Jenny Kolcun Design**
3
Design Firm **Brad Terres Design**
4
Design Firm **Boyden & Youngblutt**
5
Design Firm **Strategy One, Inc.**
6, 7
Design Firm **Stephen Burdick Design**
1.
Client *Polyair Envelope Manufacturer*
Designers Paul Wiersma, Curtis Wolowich
2.
Client *Ojo Photography*
Designer Jenny Kolcun

3.
Client *Casablanca Fan Company*
Designers Brad Terres, Matt Meehan
4.
Client *Apollo Design Technology*
Designer Todd Lemley
5.
Client *Airgate International*
Designers Brian Danaher, Jason Thompson
6.
Client *Technical Assistance Collaborative*
Designer Stephen Burdick
7.
Client *Wainwright Bank*
Designer Stephen Burdick
(opposite)
Client *Printegra*
Design Firm **TD2, S.C.**
Designer Rafael Rodrigo Córdova

DIGITAL OFFSET / TONER+
DIGITAL OFFSET / PLATE+
TRADITIONAL OFFSET+
HI RES FILM OUTPUT+
MULTIFORMAT PLOTTERS+
HIGH RES SCANNER+
DIGITAL COLOR PROOF

OFFSET DIGITAL+OFFSET TRADICIONAL+PREPRENSA DIGITAL

YELLOW MAGENTA CYAN

Offset Tradicional

Offset Digital

Preprensa Digital

Trabajando juntos

Ahora somos **Printegra**®.

Trónix y Lasergraphix nos unimos multiplicando nuestras capacidades.

Nos mantenemos a la vanguardia poniendo en tus manos la tecnología de impresión

más adecuada para cada tipo de proyecto. Ahora no importará el tamaño, el tiraje,

la técnica o el sustrato... En **Printegra**® nuestro trabajo será tu satisfacción.

Printegra®

Satisfacción
a todo color

1.

ALIANZA MEXICANA
PARA EL
DESARROLLO SOCIAL, A.C.

2.

SALGADO
& AVALOS
A B O G A D O S

3.

066

4.

Star Médica

5.

TUTTO
IN TELA

6.

VillaMusical

7.

XXVIII CONGRESO
NACIONAL
DE PEDIATRIA

MORELIA
2002

8.

9.

10.

ARTICULOS RELIGIOSOS

11.

12.

13.

14.

MEDICA PLUS

15.

1 - 15
Design Firm **Caracol Consultores SC**

1.
Client *Aplicación y Comercializadora de Pinturas*
Designer Luis Jaime Lara

2.
Client *Alianza Mexicana para el Desarrollo Social*
Designers Luis Jaime Lara, Mario A. Lara

3.
Client *Salgado Avalos Abogados*
Designers Luis Jaime Lara, Nora Rodriguez Velasco

4.
Client *Gobierno del Estado de Michoacán (Emergencias)*
Designer Luis Jaime Lara

5.
Client *Hospitales Star Médica*
Designers Luis Jaime Lara, Elizabeth Viveros

6.
Client *Tutto in Tela*
Designers Luis Jaime Lara, Myriam Zavala

7.
Client *Villa Musical*
Designers Luis Jaime Lara, Myriam Zavala

8.
Client *Congreso Nacional de Pediatría 2002*
Designer Luis Jaime Lara

9, 10.
Client *Gobierno del Estado de Michoacán (Participa)*
Designer Luis Jaime Lara

11.
Client *Artículos Religiosos Nava*
Designers Luis Jaime Lara, Myriam Zavala

12.
Client *Museo del Dulce de Morelia*
Designers Luis Jaime Lara, Myriam Zavala

13.
Client *Modstil Fashion Group*
Designer Luis Jaime Lara

14.
Client *Coord. Gral para la Atencíon al Migrante Michoacano*
Designers Luis Jaime Lara, Laura De la Vega

15.
Client *Médica Plus SC*
Designers Luis Jaime Lara, Myriam Zavala

1.

2.

3.

Northern Hills
C o u n t r y C l u b

4.

DAIGLE DESIGN

CIBO NATURALS

5.

6.

7.

1 - 7
Design Firm **Daigle Design**
1.
Client *Salmon Run House*
Designers Candace Daigle, Jessi Carpenter
2.
Client *Sakai Village*
Designer Jane Shasky
3.
Client *Rockford Asset Management*
Designer Paul Dunning
4.
Client *Northern Hills Country Club*
Designer Dan Thompson
5.
Client *Daigle Design*
Designer Kim Tebb

6.
Client *Cibo Naturals*
Designers Candace Daigle, Jane Shasky,
 Gloria Chen
7.
Client *Bainbridge Island Performing Arts*
Designers Candace Daigle, Paul Dunning
(opposite)
Client *Nestle*
Design Firm **TD2, S.C.**
Designer Rafael Rodrigo Córdova,
 Liliana Ramírez

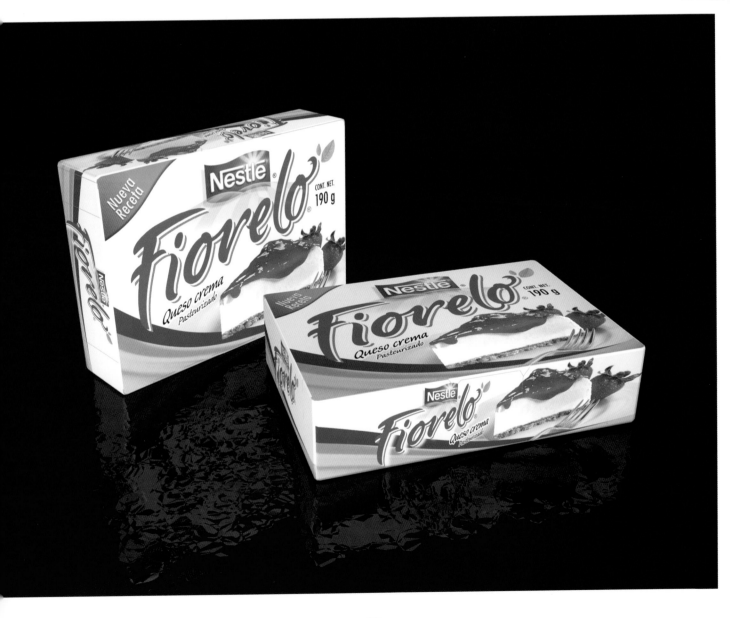

1.

2.

3.

4.

5.

6.

7.

8.

EXIMPORT

9.

10.

CETIC

11.

PATRONATO PRO RESCATE CENTRO HISTORICO

Morelia

12.

CEDEHFAC

13.

Iberotel

14.

15.

1 - 15
Design Firm **Caracol Consultores SC**

1.
Client — Master Brush
Designer — Luis Jaime Lara

2.
Client — Magnolia Pisos y Recubrimientos
Designers — Luis Jaime Lara, Myriam Zavala

3.
Client — Gobierno del Estado de Michoacán (Ludotecas)
Designers — Myriam Zavala, Luis Jaime Lara

4.
Client — Dulces Morelianos De La Calle Real
Designer — Luis Jaime Lara

5.
Client — Hortelano Campo y Jardín
Designers — Luis Jaime Lara, Georgina Luengas M.

6.
Client — Gobierno del Estado de Michoacán
Designer — Luis Jaime Lara

7.
Client — Fer Material Didáctico Infantil
Designer — Luis Jaime Lara

8.
Client — Comisión de Ferias y Exposiciones de Michoacán
Designer — Luis Jaime Lara

9.
Client — EXIMPORT
Designer — Luis Jaime Lara

10.
Client — Congreso Nacional de Escuelas particulares
Designer — Luis Jaime Lara

11.
Client — Gob. del Estado de Michoacán (Centro de Informática)
Designers — Luis Jaime Lara, Raúl Elizondo, Carlos Chávez, Víctor Rodríguez

12.
Client — Patronato pro—rescate del Centro Histórico
Designers — Luis Jaime Lara, Elizabeth Viveros S.

13.
Client — Centro de Desarrollo Humano y Familiar
Designer — Luis Jaime Lara, Elizabeth Viveros

14.
Client — Ibertol
Designer — Luis Jaime Lara

15.
Client — Caracol Consultores SC
Designers — Luis Jaime Lara, Georgina Luengas

JEFF
KROOP

1.

SUSAN SCHOEN LMT CNMT
STRUCTURAL INTEGRATION PRACTITIONER
The Rolf Method

2.

3.

SnorkelPro®
BY SCUBAPRO®

4.

THE
NURSERY & POND
COMPANY

5.

AMERICAN
NATIONAL BANK

6.

primavera
ITALIAN EATERY

7.

1, 2
Design Firm **Gouthier Design**
3
Design Firm **Smith Design**
4
Design Firm **Laura Coe Design**
5
Design Firm **Rick Cooper, Inc.**
6
Design Firm **Dotzler Creative Arts**
7
Design Firm **Dana Design**
1.
Client *Jeff Kroop, Inc.*
Designers Jonathan Gouthier, Mami Awamura
2.
Client *Susan Schoen LMT, CNMT*
Designers Jonathan Gouthier, Kiley Del Valle

3.
Client *Filmation*
Designer Eileen Berezni
4.
Client *Scub Pro*
Designers Tracy castle, Laura Coe Wright
5.
Client *The Nursery & Pond Company*
Designer Rick Cooper
6.
Client *American National Bank*
Designer Dotzler Creative Arts
7.
Client *Primavera, Italian Eatery*
Designer Dana Ezzell Gay
(opposite)
Client *Patricia Gabriela Peláez*
Design Firm **TD2, S.C.**
Designer Rafael Rodrigo Córdova

1.

2.

3.

4.

5.

6.

7.

8.

9.

GUARDIAN
Pool & Fence Systems

10.

11.

refi
real estate financing, inc.

12.

SKINREMEDIES
RENEW REFRESH REJUVENATE

13.

14.

15.

1 - 4		
Design Firm	**Maremar Graphic Design**	
5 - 13		
Design Firm	**Poonja Design, Inc.**	
14,15		
Design Firm	**Michael Niblett Design**	

1.
Client — Lilia Molina
Designer — Marina Rivón

2.
Client — Omar Haedo
Designer — Marina Rivón

3.
Client — UPR Pediatrics Dept.
Designer — Marina Rivón

4.
Client — Ivan Irizarry
Designer — Marina Rivón

5.
Client — Digital Realtor
Designer — Suleman Poonja

6 - 8.
Client — Applied Wave Research, Inc.
Designer — Suleman Poonja

9.
Client — Nissan North America, Inc.
Designer — Suleman Poonja

10.
Client — Guardian Pool and Fence Company
Designer — Suleman Poonja

11.
Client — University of California, Los Angeles
Designer — Suleman Poonja

12.
Client — Real Estate Financing, Inc.
Designer — Suleman Poonja

13.
Client — Skin Remedies
Designer — Suleman Poonja

14.
Client — The Eckholm Group
Designer — Michael Niblett

15.
Client — Green Party of Tarrant County
Designer — Michael Niblett

ATRIUM

BAXTER
**CONTINUING
EDUCATION**
www.baxter.com/ce-program

1.

2.

3.

*Partners
in Pediatrics*

4.

WIBO ALUMNI ASSOCIATION
CONNECT WITH SUCCESS

5.

ParkAvenue
Synagogue ק״ק אגודת ישרים

6.

STEAMBOAT
FOUNDATION

7.

1, 2
Design Firm **Design Moves, Ltd.**
3
Design Firm **Kevin Hall Design**
4
Design Firm **Parsons and Maxson, Inc.**
5 - 7
Design Firm **Namaro Graphic Designs, Inc.**
1.
Client *Baxter Healthcare*
Designers Laurie Medeiros Freed,
 April Weaver
2.
Client *Atrium Landscape Design*
Designers Laurie Medeiros Freed,
 April Weaver
3.
Client *Kevin Hall Design*
Designer Kevin Hall
4.
Client *Partners In Pediatrics, PC*
Designer Sean Caldwell

5.
Client *Workshop in
 Business Opportunities*
Designer Nadine Robbins
6.
Client *Park Avenue Synagogue*
Designers Nadine Robbins, Molly Ahearn
7.
Client *Steamboat Foundation*
Designers Nadine Robbins, Molly Ahearn
(opposite)
Client *Labatt USA*
Design Firm **HMS Design**
Designer Josh Laird

BOLTEK

1.

2.

3.

Real kitchen™

4.

St. Louis Mills
SM

5.

6.

7.

8.

9.

10.

11.

12.

13.

FURMAN KALLIO

INTELLECTUAL PROPERTY & TECHNOLOGY LAW

14.

15.

1, 7 - 14
Design Firm **Nancy Carter Design**
2 - 6, 15
Design Firm **Kiku Obata & Company**

1.
Client *Boltek*
Designer Nancy Carter

2.
Client *Pace Properties*
Designer Todd Mayberry

3.
Client *Great Rivers Greenway*
Designers Teresa Norton-Young,
 Troy Guzman

4.
Client *Real Kitchen*
Designer Eleanor Safe

5.
Client *The Mills Corporation*
Designer Joe Floresca

6.
Client *Pin-up Bowl*
Designer Rich Nelson

7.
Client *Average Girl, The Magazine*
Designer Nancy Carter

8.
Client *Capitol Chocolate Fountains*
Designer Nancy Carter

9.
Client *Insight Genetics*
Designer Nancy Carter

10.
Client *ITC2*
Designer Nancy Carter

11.
Client *Bay Area WoodCrafts*
Designer Nancy Carter

12.
Client *The Hen's Teeth*
Designer Nancy Carter

13.
Client *Voyages Coffee Shop*
Designer Nancy Carter

14.
Client *Furman—Kallio*
Designer Nancy Carter

15.
Client *Craft Alliance*
Designer Amy Knopf

1.

2.

3.

4.

5.

6.

7.

1, 2
 Design Firm **Jill Bredthauer**
3
 Design Firm **B² Communications**
4, 5
 Design Firm **Drotz Design**
6, 7
 Design Firm **Peggy Lauritsen Design Group**
1.
 Client *Hasna Inc.*
 Designer Jill Bredthauer
2.
 Client *Rewired Production Management*
 Designer Jill Bredthauer
3.
 Client *Bulk Stop*
 Designer Brian Berry
4.
 Client *DLP*
 Designer Dallas Drotz
5.
 Client *Puyallup Foursquare*
 Designer Dallas Drotz

6.
 Client *Direct Source, Inc.*
 Designer Michelle Ducayet
7.
 Client *Lawson Software*
 Designer John Haines
(opposite)
 Client *Labatt USA*
 Design Firm **HMS Design**
 Designer Jeff Meyer

1.

2.

3.

University of Miami
Center for Sustainable Fisheries

4.

5.

6.

7.

8.

9.

10.

PEW INSTITUTE FOR
OCEAN SCIENCE

11.

12.

13.

14.

15.

1 - 3
Design Firm **BBK Studio**
4 - 11
Design Firm **Laidlaw Gervais**
12 - 15
Design Firm **Dynapac Design Group**

1.
Client *Alpine Oral Surgery*
Designer Sharon Oleniczak

2.
Client *SitOnit Seating*
Designers Yang Kim, Kevin Budelmann,
Michele Chartier, Alison Popp,
Brian Hauch, Sharon Oleniczak

3.
Client *X-Rite*
Designers Yang Kim, Kevin Budelmann,
Michele Chartier, Alison Popp,
Brian Hauch, Sharon Oleniczak

4.
Client *University of Miami Center for
Sustainable Fisheries*
Designer David Laidlaw

5.
Client *Sturgeon Aquafarms*
Designer David Laidlaw

6.
Client *Acqualina Ocean Residences
& Resort*
Designer David Laidlaw

7.
Client *Island City Traders*
Designer David Laidlaw

8.
Client *NCORE —National Center
for Caribbean Coral Reef Research*
Designer David Laidlaw

9.
Client *Cyberknife Center of Miami*
Designer David Laidlaw

10.
Client *Xoom*
Designer David Laidlaw

11.
Client *Pew Institute for Ocean Science*
Designer David Laidlaw

12.
Client *Triton Residential Services*
Designer Lee A. Aellig

13.
Client *OutSource Technical Solutions*
Designer Lee A. Aellig

14.
Client *Lincoln Mutual
Mortgage Corporation*
Designer Lee A. Aellig

15.
Client *BlueSky Broadcast*
Designer Lee A. Aellig

Yoga Center
OF SONOMA COUNTY

1.

2.

CAFE CREOLE
RESTAURANT

3.

caffé
cottage

4.

E.S.Systems,Inc.

5.

6.

imgood.org

7.

1 - 7
Design Firm **Creative Madhouse**
1.
Client *Yoga Center of Sonoma County*
Designer Madelyn Wattigney
2.
Client *BankBlackwell*
Designer Madelyn Wattigney
3.
Client *Cafe Creole Restaurant*
Designer Madelyn Wattigney
4.
Client *Caffe Cottage*
Designer Madelyn Wattigney
5.
Client *E.S. Systems, Inc.*
Designer Madelyn Wattigney
6.
Client *FoodSummit*
Designer Madelyn Wattigney
7.
Client *ImGood.org*
Designer Madelyn Wattigney

(opposite)
Client *Wm. Bolthouse Farms*
Design Firm **HMS Design**
Designer Josh Laird

1.

2.

california's advanced fire protection

3.

BioTrek

4.

JASNA
Los Angeles 2004

5.

6.

midtown
V E N T U R A

7.

8.

64

IABC/LA
a n g e l s

9.

Montrachet

PREMIER APARTMENT HOMES

10.

REGENCY
APARTMENTS
AT SKYPORT

11.

BLUESKIES
Marketing & Public Relations Staffing Solutions

12.

Back on Track

13.

CMC

14.

BAYROCK
R E S I D E N T I A L

15.

1 - 9
Design Firm **Gunnar Swanson Design Office**
10 - 15
Design Firm **Shawver Associates, Inc.**

1.
Client — Hanham Consulting
Designer — Gunnar Swanson
2.
Client — Halstead Communication
Designer — Gunnar Swanson
3.
Client — California's Advanced Fire Protection
Designer — Gunnar Swanson
4.
Client — California State Polytechnic University Pomona
Designer — Gunnar Swanson
5.
Client — Jane Austen Society of North America
Designer — Gunnar Swanson
6.
Client — Gunnar Swanson Design Office
Designer — Gunnar Swanson

7.
Client — Midtown Ventura Community Council
Designer — Gunnar Swanson
8.
Client — County Communicators
Designer — Gunnar Swanson
9.
Client — IABC/LA The Los Angeles Chapter of the International Association of Business Communicators
Designer — Gunnar Swanson
10.
Client — Bay Rock
Designer — Rich Costa
11.
Client — SSR Realty
Designers — Rich Costa, Kyle Ogden
12.
Client — Blue Skies
Designer — Amy Krachenfels
13.
Client — Back on Track
Designer — Amy Krachenfels
14.
Client — CMC
Designers — Rich Costa
15.
Client — Bay Rock Residential
Designers — Rich Costa

INKOSIS

1.

2.

Peelle Technologies

3.

4.

VANILLA
MOON
CAFE

5.

6.

WONDERFUL
WORLD of
FLYING

7.

1 - 7
Design Firm **Creative Madhouse**
1.
Client *Inkosis*
Designer Madelyn Wattigney
2.
Client *Kiss My Pride*
Designer Madelyn Wattigney
3.
Client *Peelle Technology*
Designer Madelyn Wattigney
4.
Client *Two Topia*
Designer Madelyn Wattigney
5.
Client *Vanilla Moon Cafe*
Designer Madelyn Wattigney
6.
Client *W3 Master*
Designer Madelyn Wattigney
7.
Client *Wonderful World of Flying*
Designer Madelyn Wattigney

(opposite)
Client *Atlantic Maintenance Corp.*
Design Firm **Fiorentino Associates**
Designer Andy Eng

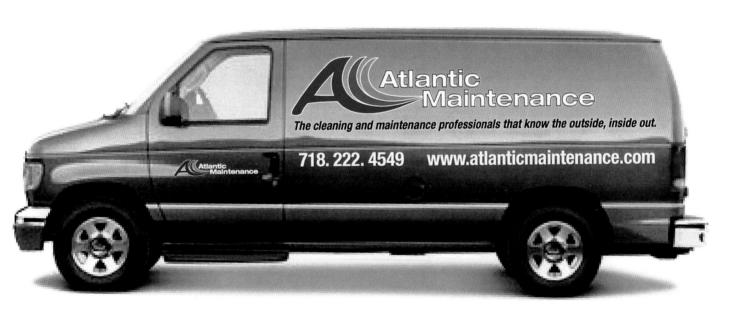

1.

7.

3.

5.

2.

4.

6.

8.

9.

Horizon
Financial Consultants

10.

FARMERS, ARTISANS, FRIENDS

EVERY SUNDAY AT BELMAR

11.

12.

BRADBURN
ROW

URBAN STYLE APARTMENT HOMES

13.

CH CULTUREHAUS

14.

15.

1.

2.

3.

4.

5.

6.

7.

1 - 7
Design Firm **CDI Studios**
1.
| Client | Child Focus of Nevada |
| Designer | Henry Martinez III |

2.
| Client | Pacific Properties |
| Designer | Mackenzie Walsh |

3.
| Client | Capital Investment Company |
| Designers | Michelle Georgilas, Eddie Roberts |

4.
| Client | Meridias Capital |
| Designers | Michelle Georgilas, Eddie Roberts |

5.
| Client | Under the Son Excavating |
| Designers | Victoria Hart, Mackenzie Walsh |

6.
| Client | Viper International |
| Designer | Casey Corcoran |

7.
| Client | Bernard Realty |
| Designer | Victoria Hart |

(opposite)
Client	Tasty Baking Company
Design Firm	**Munroe Creative Partners**
Designer	Mike Cavallaro

1.

2.

3.

4.

5.

UCLA

6.

7.

SAYBROOK

8.

9.

10.

BLOCK CONSULTING

11.

12.

13.

14.

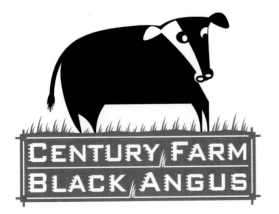

15.

1 - 5			**7.**	
Design Firm	**Lipson Alport Glass & Assoc.**		Client	*Yamano Beauty School*
6 - 9			Designers	Keith Bright, Glenn Sakamoto
Design Firm	**Bright Strategic Design**		**8.**	
10 - 15			Client	*Saybrooke Capital, LLC*
Design Firm	**Bruce Yelaska Design**		Designers	Keith Bright, Glenn Sakamoto
1.			**9.**	
Client	*Jewish Vocational services*		Client	*Alexia Foods*
Designer	Michelle Palko		Designers	Keith Bright, Glenn Sakamoto
2.			**10.**	
Client	*Film Aid International*		Client	*Saarman Construction*
Designer	Michelle Palko		Designer	Bruce Yelaska
3.			**11.**	
Client	*Direct Relief International*		Client	*Block Consulting*
Designer	Michelle Palko		Designer	Bruce Yelaska
4.			**12, 13.**	
Client	*SpringDot*		Client	*Saarman Construction*
Designer	Kevin Wimmer		Designer	Bruce Yelaska
5.			**14.**	
Client	*ARS Rescue Rooter*		Client	*Spoon Restaurant*
Designer	Lori Cerwin		Designer	Bruce Yelaska
6.			**15.**	
Client	*University of California, Los Angeles*		Client	*Century Farm Black Angus*
Designers	Keith Bright, Denis Parkhurst		Designer	Bruce Yelaska

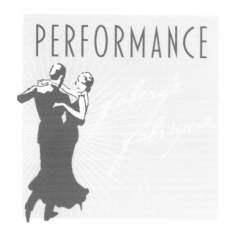

1.

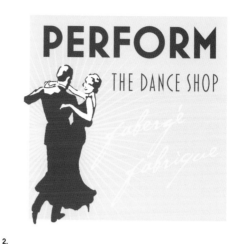

2.

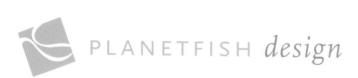

PLANETFISH *design*

3.

4.

connectionpower.com

5.

6.

SRD

7.

1 - 4
Design Firm **PlanetFish Design**
5 - 7
Design Firm **CDI Studios**
1, 2.
 Client *Fabergé Fabrique*
 Designer Felicia Lo
3.
 Client *PlanetFish Design*
 Designer Felicia Lo
4.
 Client *Cielo Systems*
 Designer Felicia Lo
5.
 Client *Connection Power*
 Designers Eddie Roberts,
 Victoria Hart

6.
 Client *Ceasars Palace*
 Designers Victoria Hart,
 Henry Marting III,
 Eddie Roberts
7.
 Client *Systems Research*
 Development
 Designers Eddie Roberts,
 Victoria Hart
(opposite)
 Client *Pinnacle Foods*
 Design Firm **Zunda Design Group**
 Designers Todd Nickel, Charles Zunda,
 Tom James

LEADERS UNITED

1.

 TWENTIETH CENTURY
S E R V I C E S , I N C.

2.

K R

3.

 CHICAGO HEALTH
connection

4.

Society of
Women Engineers
National Conference

5.

TILE ROOFING
I N S T I T U T E

6.

FUNK FL LINKO

7.

INSight

8.

FLAME RUN

9.

TM

10.

ORION

11.

coffeesmiths

12.

TAVERN

13.

Agreturns

14.

AWAKE

15.

1.

2.

3.

4.

5.

GREENBLOCK

6.

7.

1 - 7
Design Firm **The Wecker Group**
1.
 Client *Fisherman's Wharf Monterey*
 Designer Robert Wecker
2.
 Client *Daystar Sports*
 Designer Robert Wecker
3.
 Client *Mavericks Coffee House &*
 Roasting Company
 Designer Robert Wecker
4.
 Client *Portland Historic*
 Automobile Races
 Designer Robert Wecker
5.
 Client *Sage Metering*
 Designer Robert Wecker
6.
 Client *Greenblock*
 Designers Robert Wecker,
 Matt Gnibus

7.
 Client *Gold Coast Rods, Inc.*
 Designer Robert Wecker
(opposite)
 Client *Drinks Americas, Inc.*
 Design Firm **Zunda Design Group**
 Designers Pat Sullivan,
 Charles Zunda

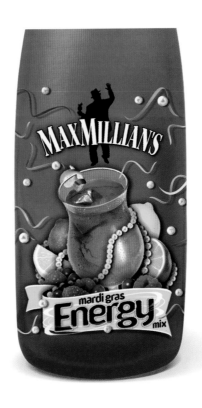

fischers fritzz

1.

Wild World

JAGDCENTER DORSTEN

2.

familyandfriends

Einfach mehr zurückbekommen.

3.

ascos

ruhrgas positioning services

4.

wortundtat

5.

EDDIE'S
MILLION DOLLAR
COOK-OFF

6.

C A R E

Center for **A**ctivity
Research and **E**ducation

7.

D A V I T A

CHILDREN'S
FOUNDATION

8.

80

9.

A Project of the USC Annenberg School and the University of Wisconsin

10.

11.

12.

OnSmile.com

the fine art of dentistry

13.

JEM EVENTS

14.

15.

1 - 5
Design Firm **Buttgereit und Heidenreich**
6 - 14
Design Firm **IE Design + Communications**
15
Design Firm **Freelance Visual Artist**

3.
Client	*family and friends*
Designers	Michael Buttgereit, Wolfram Heidenreich

4.
Client	*Ruhrgas AG, Essen, Germany*
Designer	Michael Buttgereit

5.
Client	*Wort und Tat e.v., Essen, Germany*
Designers	Michael Buttgereit, Wolfram Heidenreich

6.
Client	*Disney*
Designers	Marcie Carson, Cya Nelson

7.
Client	*CARE*
Designers	Marcie Carson, Amy Klass

8.
Client	*Davita Healthcare*
Designers	Marcie Carson, Cya Nelson

9.
Client	*Davita Healthcare*
Designer	Marcie Carson

10 - 11
Client	*University of Southern California*
Designers	Marcie Carson, Cya Nelson

12.
Client	*Fun Zone*
Designer	Marcie Carson

13.
Client	*OnSmile*
Designer	Marcie Carson

14.
Client	*JEM Events*
Designer	Marcie Carson

15.
Client	*Friends for the Youghiogheny River Lake, Inc.*
Designer	Chris M. Brioady

1.

eNTERSPORTS

2.

"Here for Good"

Community Foundation for Monterey County

3.

ARCTUROS

At Home, Around the World

4.

SAMUEL B. BENAVIDES, AIA

5.

DuBose/Kopshever
®

CHOWCHILLA

6.

7.

1 - 7
Design Firm **The Wecker Group**
1.
 Client *First Class Flyer*
 Designers Robert Wecker,
 Matt Gnibus
2.
 Client *Entersports*
 Designer Robert Wecker
3.
 Client *Community Foundation for Monterey County*
 Designer Robert Wecker
4.
 Client *Arcturos Yachts*
 Designers Robert Wecker,
 Matt Gnibus
5.
 Client *Benavides Architects*
 Designer Robert Wecker
6.
 Client *DuBose/Kopshever Chevrolet*
 Designers Robert Wecker,
 Matt Gnibus

7.
 Client *Monterey Bay Blues Festival*
 Designers Robert Wecker,
 Harry Briggs
(opposite)
 Client *Pinnacle Foods*
 Design Firm **Zunda Design Group**
 Designers Todd Nickel,
 Charles Zunda,
 Tom James

1.

2.

3.

4.

MOSQUITO MAGNET®

Fatal Attraction for Mosquitoes

5.

6.

Cromwell

7.

8.

9.

BLAIR
SCHOOL OF MUSIC

VANDERBILT UNIVERSITY

10.

VANDERBILT
HEMOSTASIS
THROMBOSIS
CLINIC

11.

Byrd
Proctor
&Mills
CERTIFIED PUBLIC ACCOUNTANTS

12.

THE
SCHIEFELBUSCH
INSTITUTE FOR
LIFE SPAN STUDIES

13.

KIDS FEEDING KIDS

14.

15.

1 - 7		
Design Firm	**Fleming & Roskelly, Inc.**	
8		
Design Firm	**Lidia Varesco Design**	
9 - 15		
Design Firm	**Ventress Design Group**	
1.		
Client	*Synqor*	
Designers	Tom Roskelly, Deb Moniz	
2.		
Client	*M4 Image Processing*	
Designers	Tom Roskelly, Deb Moniz	
3.		
Client	*Fish Teezer.Com*	
Designers	Tom Roskelly, Deb Moniz	
4 - 5		
Client	*American Biophysics Corp.*	
Designers	Tom Roskelly, Deb Moniz	
6.		
Client	*Interstate Navigation*	
Designers	Tom Roskelly, Deb Moniz	
7.		
Client	*Cromwell*	
Designers	Tom Roskelly, Deb Moniz	

8.	
Client	*Las Puertas Imports*
Designer	Lidia Varesco
9.	
Client	*Ventress Design Group*
Designer	Tom Ventress
10.	
Client	*Vanderbilt University*
Designer	Tom Ventress
11.	
Client	*Vanderbilt University—*
	Medical Center
Designer	Tom Ventress
12.	
Client	*Byrd, Proctor & Mills*
Designer	Tom Ventress
13.	
Client	*The Schiefelbusch Institute for*
	Life Span Studies
Designer	Tom Ventress
14.	
Client	*Kids Feeding Kids*
Designer	Tom Ventress
15.	
Client	*Walker Foods*
Designer	Tom Ventress

A SALOON

1.

HAMMER GOLF
PERFORMANCE & FITNESS

2.

HACKETT
PROPERTIES

3.

WarnerJoest
BUILDERS

4.

Tools for Decision

™

5.

TAYLOR BAY YACHTS, LLC

6.

ReTReAT
Living the Spa Lifestyle

7.

1 - 7
Design Firm **The Wecker Group**
1.
Client *Doubletree Hotel/Monterey*
Designer Robert Wecker
2.
Client *Hammer Golf Performance*
Designers Robert Wecker,
 Matt Gnibus
3.
Client *Hackett Properties*
Designer Robert Wecker
4.
Client *Warner Joest Builders*
Designers Robert Wecker,
 Tremayne Cryer
5.
Client *Tools for Decision*
Designers Robert Wecker,
 Matt Gnibus
6.
Client *Taylor Bay Yachts*
Designers Robert Wecker,
 Matt Gnibus

7.
Client *Retreat*
Designer Robert Wecker
(opposite)
Client *American Heritage Billiards*
Design Firm **Berni Marketing & Design**
Designers Carlos Seminario,
 Stuart Berni

American Heritage

Challenge

To uncover consumer buying habits and reposition the #2 billiards company in the U.S. to stimulate sales growth.

Solution

Repositioned American Heritage through the creation of a new branding strategy and research-based tagline that appeals to consumers looking "For the Finishing Touch" to complete a room's décor. Developed a dynamic corporate identity and website. Designed an innovative kiosk and POP display system that serves as a customizable tool to improve the buying experience.

Result

Right on cue: new positioning and kiosk/sales resonate with target audience yielding exponential sales growth.

Quote

"Our new corporate identity and repositioning have really improved our image. The interactive point of purchase system is a first in the industry and consumers really love it. We look forward to working with Berni for years to come."

Joe Pucci, President

www.bernidesign.com

BERNI

◆ FOR THE FINISHING TOUCH ◆

1.

2.

FREE OTION™

3.

CHURCH CENTERED
M I S S I O N

4.

rai.2028
RESPONSIVE ARTIFICIAL INTELLIGENCE

5.

METRIC REPORTS
REPORTING ALIGNED TO YOUR GOALS™

6.

TIMOTHY PAUL
C A R P E T S + T E X T I L E S

7.

NORTH GENERAL
H O S P I T A L
Growing With Our Community, Caring For Your Health

8.

K O O C H E S
hand made carpets

9.

VERT SHIRTS

10.

WINTERTIME

11.

design nut

12.

NORGLOBE

13.

EQUALITY
VIRGINIA

14.

the**MEDIA**fund

15.

1 - 3
Design Firm **Hornall Anderson Design Works**
4 - 6
Design Firm **StudioNorth**
7 - 15
Design Firm **Design Nut**

1.
Client — *TruckTrax*
Designers — Jack Anderson, Gretchen Cook, Kathy Saito

2.
Client — *Pace International*
Designers — Jack Anderson, Sonja Max, Andrew Smith, Kathy Saito

3.
Client — *FreeMotion*
Designers — Jack Anderson, Kathy Saito, Sonja Max, Henry Yiu, Alan Copeland

4.
Client — *Joel Holm Ministries*
Designers — Allison Misevich, Chris Trinco

5.
Client — *StudioNorth*
Designer — Mark Schneider

6.
Client — *Metric Reports*
Designer — Allison Misevich

7.
Client — *Timothy Paul Carpets + Textiles*
Designer — Brent M. Almond

8.
Client — *North General Hospital/Sutton Group*
Designer — Brent M. Almond

9.
Client — *Kooches Hand Made Carpets*
Designer — Brent M. Almond

10.
Client — *David Cohen*
Designer — Brent M. Almond

11.
Client — *Round House Theatre/Kircher, Inc.*
Designer — Brent M. Almond

12.
Client — *Design Nut, LLC*
Designer — Brent M. Almond

13.
Client — *NorGlobe, LLC*
Designer — Brent M. Almond

14.
Client — *Equality Virginia*
Designer — Brent M. Almond

15.
Client — *The Media Fund/Elevation*
Designer — Brent M. Almond

1.

2.

National Interpreting Service

3.

4.

MONTEREY
PENINSULA
COUNTRY CLUB
PEBBLE BEACH, CA

5.

6. The Drink Tank

MYTHMAKER
CREATIVE SERVICES

7.

1 - 5
Design Firm **The Wecker Group**
6, 7
Design Firm **Faia Design**
1.
 Client *Wright Williams & Kelly*
 Designers Robert Wecker,
 Matt Gnibus
2.
 Client *Monterey Peninsula*
 Dental Group
 Designer Robert Wecker
3.
 Client *Language & Line Services*
 Designer Robert Wecker
4.
 Client *Mazda Raceway Laguna Seca*
 Designer Robert Wecker
5.
 Client *Monterey Peninsula Country Club*
 Designer Robert Wecker
6.
 Client *Odwalla, Inc.*
 Designer Don Faia

7.
 Client *Mythmaker Creative Services*
 Designers Don Faia,
 Tom Dill
(opposite)
 Client *Owensby Development*
 Design Firm **Berni Marketing & Design**
 Designers Carlos Seminario,
 Stuart Berni

Owensby Development

Challenge

To launch a dynamic
national brand
for a car wash
chain with broad
demographic appeal.

Solution

Creation of shiny, new name and
identity system that is leveraged
into multiple consumer touch-points
to build brand equity.

Result

On time, on target, and on budget.
Positive perception of quality service
achieved with consumers.

Quote

"We needed the look and feel of a national brand
right out of the gate. Berni's expertise and experience
working with startups made all the difference.
We hit the ground running."

Charles Owensby, Principal

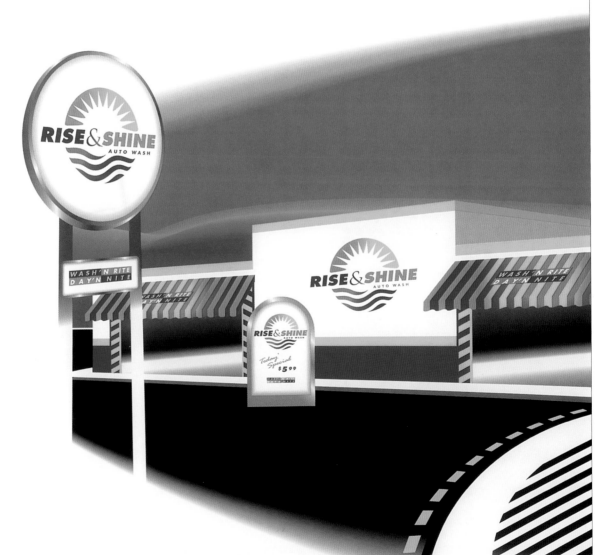

1.

2.

Edward THE SECOND

3.

4.

5.

6.

7.

8.

CYCLE

9.

ᵤfit ™

10.

SeaTac
PACKAGING MFG. CORP.

11.

PENINSULA
APARTMENTS

12.

GaggleNet
safe e-mail for students

13.

NEAR
NorthEast Area Renaissance
Neighborhood Association

14.

AGAPE
CHRISTIAN
CHURCH

15.

1 - 6
Design Firm **Jeff Fisher LogoMotives**
7
Design Firm **Hornall Anderson Design Works**
8 - 12
Design Firm **Gloria Chen**
13
Design Firm **ZENN Graphic Design**
14
Design Firm **Minx Design**
15
Design Firm **Redpoint Design**

1 - 6.
Client *triangle productions!*
Designer Jeff Fisher
7.
Client *Freerein*
Designers Jack Anderson, Mark Popich,
 Tobi Brown, John Anicker,
 Bruce Stigler, Steffanie Lorig,
 Ensi Mofasser, Elmer dela Cruz,
 John Anderle, Gretchen Cook

8.
Client *Word Sniffer, Inc.*
Designer Gloria Chen
9, 10.
Client *SportsArt American, Inc.*
Designers Gloria Chen, David Littrell
11.
Client *SeaTac Packaging Mfg. Corp.*
Designer Gloria Chen
12.
Client *Peninsula Apartments*
Designer Gloria Chen
13.
Client *Gaggle.Net*
Designer Zengo Yoshida
14.
Client *Northeast Area Renaissance*
Designer Cecilia Sveda
15.
Client *Agape Christian Church*
Designer Clark Most

1.

2.

3.

4.

CRUSADERS

6.

5.

7.

1 - 7
Design Firm **MFDI**
1.
 Client *Bridgehampton Motoring Club*
 Designer Mark Fertig
2.
 Client *All About Moving*
 Designer Mark Fertig
3.
 Client *Think Burst Media*
 Designers Mark Fertig,
 Kevin Pitts
4.
 Client *Luxor Cab Company*
 Designer Mark Fertig
5.
 Client *Susquehanna University*
 Designer Mark Fertig
6.
 Client *Intersymbol Communications*
 Designer Mark Fertig
7.
 Client *Labels-R-Us*
 Designers Mark Fertig,
 Kevin Pitts

(opposite)
Design Firm **Berni Marketing & Design**
Designers Carlos Seminario,
 Stuart Berni

FarmStores Dairy

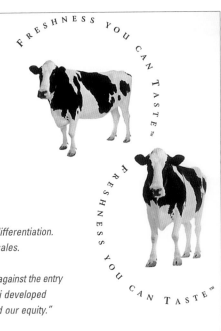

FRESHNESS YOU CAN TASTE™

FRESHNESS YOU CAN TASTE™

Challenge

To update the brand identity of a dominant local retailer to compete against national brands with a complete line of dairy products.

Solution

Refreshed positioning and packaging graphics to create a memorable brand that capitalizes on farm-fresh taste.

Result

Greater shelf presence due to product differentiation. Enhanced customer perception. Rising sales.

Quote

"We needed a fresh new look to compete against the entry of national brands into our market. Berni developed a terrific branding system that leveraged our equity."

Manny Portuondo, Owner

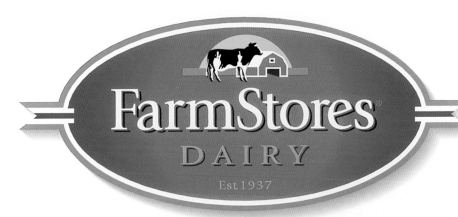

www.bernidesign.com

JAYRAY **A PLACE TO THINK**

1.

2.

3.

4.

5.

6.

M·U·S·I·C
D·A·N·C·E BUCKMAN D·R·A·M·A
SCHOOL
VISUAL ARTS

7.

FRAME THE
FUTURE
BUCKMAN ARTS MAGNET

8.

classmates·com®

9.

10.

bucky®

11.

attenex

12.

ORIVO

13.

14.

WEST COAST AQUATICS

15.

1, 2
Design Firm **JayRay**
3 - 6
Design Firm **Gloria Chen**
7, 8
Design Firm **Jeff Fisher LogoMotives**
9 - 15
Design Firm **Hornall Anderson Design Works**

1.
Client *JayRay*
Designer Tom Cheevers

2.
Client *Fulcrum Foundation*
Designer Craig Wright

3 - 6.
Client *WRFF Corp.*
Designers Gloria Chen, David Littrell

7, 8.
Client *Buckman School*
Designer Jeff Fisher

9.
Client *Erickson McGovern*
Designers John Hornall, Kathy Saito,
 Henry Yiu

10.
Client *Classmates.com*
Designers John Hornall, John Anicker,
 Debra McCloskey, Gretchen Cook,
 John Anderle, Mary Chin Hutchison

11.
Client *Bucky*
Designers Jack Anderson, Mary Hermes,
 Gretchen Cook, Henry Yiu,
 Elmer dela Cruz

12.
Client *Attenex Corporation*
Designers Katha Dalton, Jana Wilson Esser

13.
Client *Orivo*
Designers Jack Anderson, Andrew Wicklund,
 Henry Yiu

14.
Client *Active Wear*
Designers Jack Anderson, Kathy Saito,
 Gretchen Cook

15.
Client *West Coast Aquatics*
Designers Jack Anderson, Sonja Max

1.

2.

3.

EMBRYO

4.

SOMA
SOMAmotors.com

5.

6.

7.

1 - 7
Design Firm **MFDI**
1.
 Client *Advanced Audi Volkswagen*
 Designer Mark Fertig
2.
 Client *The Eccentric Gardener
 Plant Company*
 Designer Mark Fertig
3.
 Client *True Hire*
 Designer Mark Fertig
4.
 Client *Embryo Media*
 Designer Mark Fertig
5.
 Client *Soma Motors*
 Designer Mark Fertig

6.
 Client *Chat University*
 Designers Mark Fertig,
 Kevin Pitts
7.
 Client *Seriously Fun Games*
 Designer Mark Fertig
(opposite)
 Client Castleberry Foods
 Design Firm **Berni Marketing & Design**
 Designers Carlos Seminario,
 Stuart Berni

Black Rock Cattle Company

Challenge

To create an entirely new brand that would dominate the premium chili category in today's mass merchandisers.

Solution

Berni develops a compelling new brand name, and then creates the strong and hearty Black Rock brand image which captures the value-conscious consumer looking for a new taste sensation. Results indicated that a western heritage look and feel best supports the overall brand promise.

Result

Right on track: New look, combined with an appetizing multi-pack corralled consumers.

Quote

"The restaurant-quality premium beef Black Rock brand is a gotta have for our stores."

Buyer, Big Box Stores

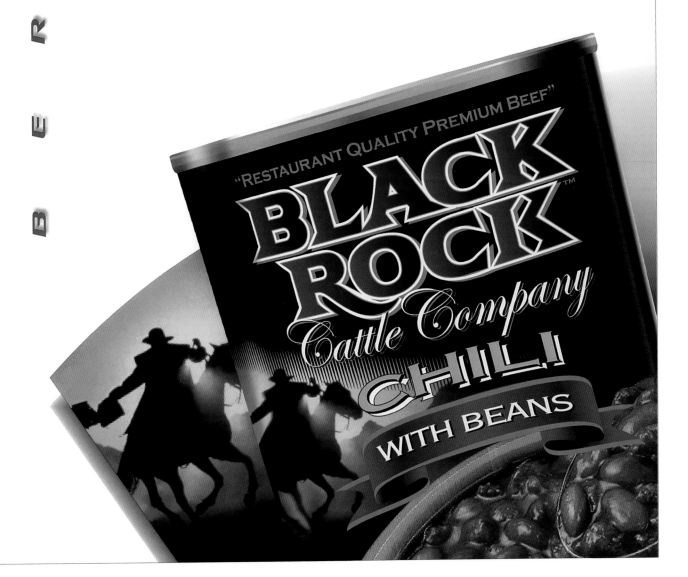

BERNI

www.bernidesign.com

1.

2.

3.

4.

b-hiue

5.

 aggregate

6.

7.

8.

9.

10.

11.

12.

13.

14.

15.

1 - 7
Design Firm **And Partners, NY**

8 - 15
Design Firm **Cave**

1.
Client National Council of Jewish Women
Designers David Schimmel, Susan Brzozowski

2.
Client Delta Asset Management
Designers David Schimmel, Aimee Sealfon

3.
Client NYU Hospital for Joint Diseases
 Center for Children
Designer David Schimmel

4.
Client SpecLogix, Inc.
Designers David Schimmel, Aimee Sealfon,
 Christine Chow, Suzie Brickley,
 Jennifer Gibbs

5.
Client Bronstein & Berman Photographers
 B-Hive Productions
Designers David Schimmel, Tyler Small

6.
Client Aggregate
Designer David Schimmel

7.
Client BMW of North America, LLC
Designers David Schimmel,
 Eugene Timmerman

8.
Client Intellibrands
Designer Matt Cave

9.
Client Policy Funding
Designer Matt Cave

10 - 12.
Client Southern Specialties
Designers David Edmundson, Matt Cave

13.
Client Mathew Forbes Romer Foundation
Designers David Edmundson, Matt Cave

14.
Client Señor Roof
Designers David Edmundson, Matt Cave

15.
Client Bluefish Concierge
Designers David Edmundson, Matt Cave

1.

2.

3.

4.

5.

6.

7.

1 - 7
Design Firm **MFDI**
1.
Client Computer Environments
Designer Mark Fertig
2.
Client Pizza House Restaurant
Designer Mark Fertig
3.
Client XSalvage.com
Designer Mark Fertig
4.
Client Member Bridge
Designer Mark Fertig
5.
Client Quarry Outfitters
Designer Mark Fertig

6.
Client Direct Met
Designer Mark Fertig
7.
Client H-Net.org
Designers Mark Fertig,
 David Imhoof

(opposite)
Client SDC Designs
Design Firm **Berni Marketing & Design**
Designers Carlos Seminario,
 Stuart Berni

Karishma

Challenge

*To launch a new
product line with an
innovative proprietary
brand for a prominent
jewelry wholesaler.*

Solution

*Romancing both jewelry retailers and consumers
alike, an elegant and captivating brand name and
identity were translated to positioning, POP display,
structural packaging and graphics, and supporting
sales collateral.*

Result

*Brilliant success. Dazzled retail target market.
Expanded distribution opportunities.*

Quote

*We needed a partner to launch our first new brand. Berni walked
us through the process and we are delighted with the results.
Sales are up. The Berni team was great to work with."*

Abhay Javeri, Principal

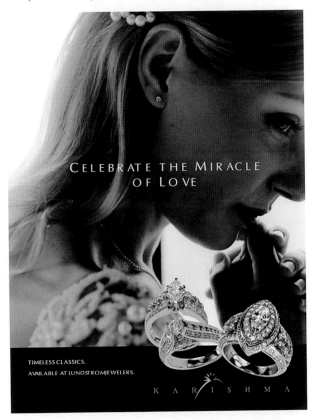

CELEBRATE THE MIRACLE OF LOVE

TIMELESS CLASSICS.
AVAILABLE AT LUNDSTROM JEWELERS.

KARISHMA

www.bernidesign.com

KARISHMA

TIMELESS CLASSICS

1.

2.

3.

4.

5.

6.

7.

8.

AELP
ASSOCIAÇÃO DE
ECONOMISTAS
DE LÍNGUA
PORTUGUESA

9.

Mendes

10.

INSTITUTO
CRIANÇAVIDA

11.

FÓRUM
PARAENSE
DE DESENVOLVIMENTO
50 anos de mineração na Amazônia

12.

MOSTRA
Ckom
feng shui

13.

Água em dia.
Prêmio à vista.

14.

a s s o c i a ç ã o
Amigos
do Theatro
da Paz

15.

1.

2.

3.

4.

5.

6.

7.

1 - 4
Design Firm **MFDI**
5 - 7
Design Firm **Monderer Design**

1.
Client *Next Objects Incorporated*
Designer Mark Fertig

2.
Client *The Daily Item/Sunbury Broadcasting*
Designers Mark Fertig, Leslie Imhoof, Scott Spector

3.
Client *Four Color Fantasies Collectible Comics*
Designer Mark Fertig

4.
Client *Eurythma*
Designer Mark Fertig

5.
Client *Zaiq Technologies*
Designer Stewart Monderer

6.
Client *Sockeye Networks*
Designes Stewart Monderer, Jeffrey Gobin

7.
Client *EqualLogic, Inc.*
Designer Stewart Monderer
(opposite)
Client *Lennar*
Design Firm **Berni Marketing & Design**
Designers Carlos Seminario, Stuart Berni

106

B E R N I

MARKETING | DESIGN

50 Years of Homebuilding

Lennar Corporation

Challenge

How to consolidate over 21 unique brands under one cohesive Brand Architecture System for America's leading home builder.

Solution

Development of a forward looking brand strategy that highlights and promotes Lennar's unique marketing platforms while consolidating twenty-one brands down to two. Update and contemporize corporate identity to build equity with customers and foster teamwork internally.

Old brandmark

Result

Launched in their 50th year anniversary, Lennar is now the "darling of Wall Street" with its stock soaring up 60% since initiating the Brand Strategy Program. Its new image and consumer-oriented positioning of "Quality. Value. Integrity." inspires home buyers, Associates and Wall Street simultaneously.

Quote

"Our new identity and slogan more accurately reflect who we are and what we do. The Berni team did a great job with both our brand strategy and execution. Our entire company is excited about our new image."

Kay Howard
Director of Communications

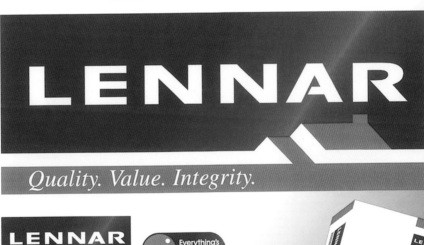

www.bernidesign.com

107

Stone Crossing

at Middle Creek

1.

MoJo

2.

3.

latitude

townhomes for **boundless** living

4.

RIDE THE EXPLORER
LEWIS & CLARK SHUTTLE

5.

6.

THE BEAN COUNTER

VEGGIE DELI & SOUP BAR

7.

BioZell

8.

spectrum *media*

9.

10.

11.

12.

13.

14.

15.

1 - 5
Design Firm **Noble Erickson Inc**.
6 - 15
Design Firm **Imagine**

1.
Client *Woodmont Development LLC*
Designers Jackie Noble, Lisa Scheideler

2.
Client *Mojo Coffee Shop*
Designers Jackie Noble, Lisa Scheideler

3.
Client *City of Black Hawk*
Designers Steven Erickson, Kevin Penland

4.
Client *Townhomes North LLC*
Designers Jackie Noble, Robin Ridley

5.
Client *Destination: The Pacific/N.P.S.*
Designers Jackie Noble, Steven Erickson,
Kevin Penland, Jeff Lukes

6.
Client *Carringtons Wine & Beer Merchants*
Designer David Caunce

7.
Client *The Bean Counter*
Designer David Caunce

8.
Client *The Visual Connection (TVC)*
Designer David Caunce

9.
Client *Spectrum Media,
Digital Tele Communications*
Designer David Caunce

10, 11.
Client *The Jammy Dodgers*
Designer David Caunce

12, 13.
Client *Pastiche*
Designer David Caunce

14.
Client *Loomland*
Designer David Caunce

15.
Client *Adam Day, Decorator*
Designer David Caunce

1.

GROUNDWATER PROTECTION AREA

COLUMBIA SOUTH SHORE

2.

3.

4.

5.

6.

7.

1 - 7
Design Firm **Dotzero Design**

1.
Client *Scottsdale Christian Academy*
Designers Jon Wippich, Karen Wippich

2.
Client *Portland Water Bureau*
Designers Jon Wippich, Karen Wippich

3.
Client *ALS Association*
Designers Jon Wippich, Karen Wippich

4.
Client *Davis Agency/Longbottom Coffee*
Designers Jon Wippich, Karen Wippich

5 - 7.
Client *Standard Companies*
Designers Jon Wippich, Karen Wippich

(opposite)
Client *Banco Popular Dominicano, C. por A.*
Design Firm **Muts&Joy&Design**
Designers Katherine Hames, Gisele Sangiovanni, Tom Delaney

WORLD WIDE BEER FROM THE WORLD WIDE WEB

1.

2.

3.

THE WHITE PEG

4.

5.

travelbeam

corporate travel management

6.

urban oasis

7.

8.

112

9.

10.

11.

12.

13.

14.

15.

1 - 13
 Design Firm **Imagine**
14
 Design Firm **Ervin Marketing**
15
 Design Firm **One Hundred Church St.**

1.
 Client *Carringtons Wine & Beer Merchants*
 Designer David Caunce
2.
 Client *Anthem Productions*
 Designer David Caunce
3.
 Client *Steen Agro/Crossover Pictures*
 Designer David Caunce
4.
 Client *The White Peg Laundry Co.*
 Designer David Caunce
5.
 Client *Fido Communications*
 Designer David Caunce
6.
 Client *Travel Beam*
 Designer David Caunce

7.
 Client *Republic PR/*
 Royal Horticultural Soc.
 Designer David Caunce
8.
 Client *Manchester Bicycle Couriers*
 Designer David Caunce
9.
 Client *Simply Clean*
 Designer David Caunce
10.
 Client *Clare Simmons*
 Designer David Caunce
11.
 Client *Alice May*
 Designer David Caunce
12.
 Client *PSA*
 Designer David Caunce
13.
 Client *Ian Finlay Architects/*
 MEDC/Urban Solutions
 Designer David Caunce
14.
 Client *Act 2*
 Designer Jean Corea
15.
 Client *Four Paws Animal Rescue*
 Designer R.P. Bissland

1.

2.

3.

4.

5.

6.

7.

1 - 7
Design Firm **Dotzero Design**
1, 2.
 Client *Unicru*
 Designers Jon Wippich, Karen Wippich
3.
 Client *Do It For Peace*
 Designers Jon Wippich, Karen Wippich
4.
 Client *Chit Chat Coffee Shop*
 Designers Jon Wippich, Karen Wippich
5.
 Client *The Neighborhood*
 Designers Jon Wippich, Karen Wippich
6.
 Client *Dotzero*
 Designers Jon Wippich, Karen Wippich

7.
 Client *CMD/Bridge Port Brewing Co.*
 Designers Jon Wippich, Karen Wippich
(opposite)
 Client *BancoLeón, S.A.*
 Design Firm **Muts&Joy&Design**
 Designers Muts Yasumura,
 Katherine Hames,
 Gisele Sangiovanni,
 Tom Delaney

aQuantive

1.

TEAOLOGY

2.

(*poetry center san josé*)

3.

VIAMQ

4.

artscouncil
silicon valley

5.

CAMP collaborative
arts marketing partnership

6.

buiLD

7.

CONNOISSEUR
HAWAII

8.

WATERLADIES

9.

POWER UP ★ Alabama

10.

MAUI BAY

11.

12.

13.

14.

15.

1, 2.
Design Firm **Hornall Anderson Design Works**
3 - 7
Design Firm **Joe Miller's Company**
8 - 13
Design Firm **John Wingard Design**
14, 15.
Design Firm **Studio Moon**

1.
Client *aQuantive Corporation*
Designers Jack Anderson, Kathy Saito,
 Henry Yiu, Sonja Max,
 Gretchen Cook

2.
Client *Teaology*
Designers Jana Nishi, Sonja Max,
 Mary Chin Hutchison

3.
Client *Poetry Center San Jose*
Designer Joe Miller

4.
Client *Willow Technology*
Designer Joe Miller

5, 6.
Client *Arts Council Silicon Valley*
Designer Joe Miller

7.
Client *Build*
Designer Joe Miller

8.
Client *Connoisseur Hawaii*
Designer John Wingard

9.
Client *The WaterLadies*
Designer John Wingard

10.
Client *Alabama Rural Electric Association*
Designer John Wingard

11.
Client *Taveuni Development Company*
Designer John Wingard

12.
Client *Hawaiian Xtreme Sports Television*
Designer John Wingard

13.
Client *Lei Lei's Bar & Grill*
Designer John Wingard

14.
Client *Mill Valley Kids Company*
Designer Tracy Moon

15.
Client *Mill Valley Baby Company*
Designer Tracy Moon

1.

2.

3.

4.

5.

6.

7.

1 - 7
Design Firm **Dotzero Design**
1, 2.
Client *CMD/Bridgeport Brewing Co.*
Designers Jon Wippich, Karen Wippich
3.
Client *Scottsdale Christian Academy*
Designers Jon Wippich, Karen Wippich
4.
Client *Kalberer*
Designers Jon Wippich, Karen Wippich
5.
Client *BIA Deaf Translaters*
Designers Jon Wippich, Karen Wippich
6.
Client *Unicru*
Designers Jon Wippich, Karen Wippich

7.
Client *Do It For Peace*
Designers Jon Wippich, Karen Wippich
(opposite)
Client *Varela Hermanos, S.A.*
Design Firm **Muts&Joy&Design**
Designers Tom Delaney,
 Toni Kurrasch

Thermage

Reshaping Your Future

1.

2.

Mindworks

3.

Passport Travel Spa

PTS

4.

CHESAPEAKE

· MARKET ·

Regional Food & Wine

5.

BEST of AMERICA

6.

WomenRock

7.

HOUSTON

THE REAL TEXAS

8.

120

9.

10.

11.

12.

Kids works

13.

JOURNEY
CHURCH

14.

KEITH'S HOME
RESTORATION
Repair Revise Reproduce

15.

1
 Design Firm **Studio Moon**
2
 Design Firm **Hornall Anderson Design Works**
3 - 13
 Design Firm **Silvester & Tafuro**
14, 15
 Design Firm **Ray Braun Design**
1.
 Client *Thermage, Inc.*
 Designers Tracy Moon, Monica Toan
2.
 Client *GGLO Architects*
 Designers Debra McCloskey, Tobi Brown,
 Steffanie Lorig, Ensi Mofasser
3.
 Client *Stellar*
 Designers Howard York, Monica Kominami
4.
 Client *Passport Travel Spa*
 Designers Howard York, Monica Kominami

5, 6.
 Client *Regional Retail Concepts*
 Designer Howard York
7.
 Client *Regional Retail Concepts*
 Designers Howard York, Monica Kominami,
 Leah York
8 - 12.
 Client *Hudson Group*
 Designer Howard York
13.
 Client *Hudson Group*
 Designers Howard York, Monica Kominami
14.
 Client *Journey Church*
 Designer Ray Braun
15.
 Client *Keith's Home Restoration*
 Designer Ray Braun

1.

(j)(w)(d) john wingard design

2.

3.

publicity connections

4.

INSight

5.

TravelP**O**RT.

A CENDANT COMPANY

6.

TERRAVIDA COFFEE

7.

1
Design Firm **John Wingard Design**
2
Design Firm **Cave**
3
Design Firm **Noble Erickson Inc.**
4 - 7
Design Firm **Hornall Anderson Design Works**
1.
 Client *John Wingard Design*
 Designer John Wingard
2.
 Client *Questinghound Technologies*
 Designers David Edmundson,
 Matt Cave
3.
 Client *Publicity Connections*
 Designer Jackie Noble
4.
 Client *InSite Works Architects*
 Designers John Anicker, Kathy Saito,
 Henry Yiu, Sonja Max

5.
 Client *Travelport*
 Designers Lisa Cerveny, Andrew Wicklund,
 Andrew Smith, Jana Nishi,
 Hillary Radbill
6.
 Client *TerraVida Coffee*
 Designers Jack Anderson, Sonja Max,
 James Tee, Tiffany Place,
 Elmer dela Cruz, Jana Nishi
7.
 Client OneWorld Challenge
 Designers Jack Anderson, John Anicker,
 Andrew Smith, Andrew Wicklund,
 Mary Hermes, John Anderle
(opposite)
 Client *Seafarer Baking Co.*
 Design Firm **Sabingrafik, Inc.**
 Designers Tracy Sabin, Bridget Sabin

1.

2.

3.

4.

5.

6.

Fitness Equipment Expert

7.

8.

9.

10.

11.

12.

SPANISH PEAKS

BIG SKY MONTANA

13.

SUNDANCE

14.

15.

1 - 15
Design Firm **Sabingrafik, Inc.**
1.
 Client *San Diego Zoo*
 Designers Tracy Sabin, Kevin Stout
2.
 Client *Coastal Plastic Surgery*
 Designers Tracy Sabin, Cindy White
3, 4.
 Client *Amerisports Bar & Grill*
 Designers Tracy Sabin, Joel Sotelo
5.
 Client *Newcastle Beer*
 Designers Tracy Sabin, Mike Brower
6.
 Client *MLB Advance Media*
 Designers Tracy Sabin, Ian Jensen
7.
 Client *Fitness Equipment Expert*
 Designers Tracy Sabin, Mary McNulty
8.
 Client *Paragon Realty & Financial, Inc.*
 Designer Tracy Sabin

9.
 Client *Beithan/Hessler*
 Designers Tracy Sabin, Peter Oehjne
10.
 Client *Bottleneck Blues Bar*
 Designers Tracy Sabin, Joel Sotelo
11, 12.
 Client *Amerisports Bar & Grill*
 Designers Tracy Sabin, Joel Sotelo
13.
 Client *Spanish Peaks*
 Designers Tracy Sabin, James Wiesinger
14.
 Client *Sundance*
 Designers Tracy Sabin, Craig Fuller,
 Sandra Sharp
15.
 Client *TYR Motorsports*
 Designers Tracy Sabin, Jim Davis

SURGE!

BLACKWATCH /////**RACING** /

FLIGHTWORKS, Inc.

Saddleback packaging

entel

BLACK DOG INSTITUTE

7.

1 - 6
Design Firm **Ciro Design**
7
Design Firm **John Bevins Pty Limited**

1.
Client IDSA Western District
Designer Katrina Luong
2.
Client ASHFI
Designer Alisa Schroeder
3.
Client Blackwatch Racing
Designer Katrina Luong
4.
Client Saddleback Packaging
Designer Juan Valadez
5.
Client Flightworks Inc.
Designer Nora Gard
6.
Client Entel
Designer Jimmy Matsuki

7.
Client Black Dog Institute
Designers John Bevins,
 Cato Purnell Partners
(opposite)
Client Adra Soaps
Design Firm **Sabingrafik, Inc.**
Designer Tracy Sabin

handmade natural soaps

Sabingrafik
I N C O R P O R A T E D

1.

HAWKS POINTE
OLD CREEK RANCH

2.

EASTLAKE
VISTAS

3.

4.

5.

WESTERN
ILLINOIS
UNIVERSITY

6.

LA COSTA
GREENS

7.

8.

FALCON RIDGE

OLD CREEK RANCH

9.

DOVE VALLEY

OLD CREEK RANCH

10.

IDYLLWILDE

PARKER COLORADO

11.

WATERRIDGE

12.

string beans

13.

REGION2020
WORKING TOGETHER TO SHAPE OUR FUTURE
SAN DIEGO ASSOCIATION OF GOVERNMENTS

14.

LA COSTA OAKS

15.

1 - 15
Design Firm **Sabingrafik, Inc.**

1.
Client *Sabingrafik, Inc.*
Designer Tracy Sabin

2.
Client *Old Creek Ranch*
Designers Tracy Sabin, Stephen Sharp

3.
Client *Eastlake Vistas*
Designers Tracy Sabin, Dennis Zimmerman

4.
Client *Sandhurst Foundation*
Designers Tracy Sabin, James Dewar

5.
Client *Simple Green*
Designers Tracy Sabin, Mike Brower

6.
Client *Western Illinois University*
Designers Tracy Sabin, Victoria Primicias

7.
Client *La Costa Greens*
Designers Tracy Sabin, Stephen Sharp

8.
Client *University of North Carolina
 at Chapel Hill*
Designers Tracy Sabin, Victoria Primicias

9, 10.
Client *Old Creek Ranch*
Designers Tracy Sabin, Stephen Sharp

11.
Client *Idyllwilde*
Designers Tracy Sabin, Craig Fuller,
 Sandra Sharp

12.
Client *WaterRidge*
Designers Tracy Sabin, Stephen Sharp

13.
Client *String Beans*
Designers Tracy Sabin, Mike Nelson

14.
Client *San Diego Association
 of Governments*
Designers Tracy Sabin, Mary McNulty

15.
Client *La Costa Oaks*
Designers Tracy Sabin, Stephen Sharp

1.

2.

3.

4.

5.

6.

7.

1, 2
Design Firm **The Hayden Group**
3 - 7
Design Firm **Rottman Creative Group**
1.
Client *Sti In-Store Merchandising*
Designer Craig Weber
2.
Client *The Hayden Group*
Designer Ellen Rudy
3.
Client *The Wood Bore Co.*
Designers Gary Rottman,
 Jenna Holcombe
4.
Client *Atlantic Firestopping*
Designer Jenna Holcombe

5.
Client *LaPlata BrewHouse Coffee's*
Designer Jenna Holcombe
6.
Client *Calvert County Department of*
 Economical Development
Designer Gary Rottman
7.
Client *LaPlata BrewHouse Coffee's*
Designer Jenna Holcombe
(opposite)
Client *Caffe Ibis*
Design Firm **One Hundred Church St.**
Designer R.P. Bissland

CAFFE IBIS

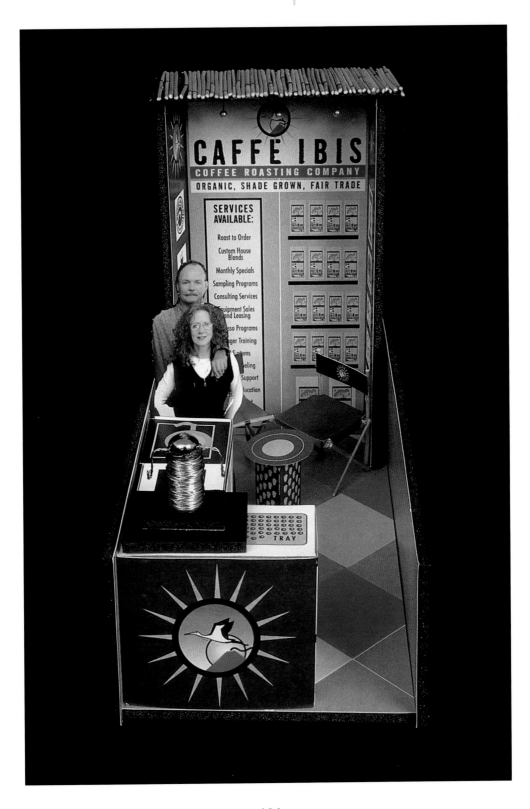

Clean Carpet
Services

1.

sad robot

2.

SHIFT

3.

4.

5.

6.

NORTHWEST
BIOTHERAPEUTICS

7.

CAFFÈ UMBRIA™

8.

9.

Hemophilia Nurse Partnership

10.

11.

12.

13.

14.

15.

1 - 9		
Design Firm	**Studio Rayolux**	
10 - 12		
Design Firm	**Design Moves, Ltd.**	
13 - 15		
Design Firm	**Hornall Anderson Design Works**	
1.		
Client	*Clean Carpet Service*	
Designer	Thad Boss	
2.		
Client	*Sad Robot Records*	
Designer	Thad Boss	
3, 4.		
Client	*Shift*	
Designer	Thad Boss	
5.		
Client	*Drunkinseattle.com*	
Designer	Thad Boss	
6.		
Client	*Vena Cava Records*	
Designer	Thad Boss	
7.		
Client	*Northwest Biotherapeutics*	
Designer	Thad Boss	
8.		
Client	*Caffé Umbria Coffee Roasting Company*	
Designer	Thad Boss	

9.		
Client	*PWI Technologies*	
Designer	Thad Boss	
10.		
Client	*Baxter Healthcare*	
Designers	Laurie Medeiros Freed, William R. Sprowl	
11.		
Client	*GlobalView*	
Designers	Laurie Medeiros Freed, William R. Sprowl	
12.		
Client	*Phar MEDium Healthcare Corporation*	
Designers	Laurie Medeiros Freed, William R. Sprowl	
13.		
Client	*Seattle Convention & Visitors Bureau*	
Designers	Lisa Cerveny, Jack Anderson, Bruce Branson-Meyer, Mark Popich	
14.		
Client	*Seattle Sonics*	
Designers	Jack Anderson, Mark Popich, Andrew Wicklund, Elmer dela Cruz	
15.		
Client	*Lincoln Square*	
Designers	Jack Anderson, Katha Dalton, Gretchen Cook, Sonja Max	

1.

2.

3.

4.

TICK DATA

5.

6.

7.

1
Design Firm **Shimokochi—Reeves**
2 - 4
Design Firm **Im-aj Communications & Design, Inc.**
5 - 7
Design Firm **Alliant Studios**

1.
Client *Jambo Tech*
Designer Mamoru Shimokochi

2.
Client *U.S. Title & Closing Company*
Designers Jami Ouellette, Mark Bevington, Lee Kosa

3.
Client *Meeting Street*
Designers Jami Ouellette, Lee Kosa

4.
Client *Sheilds Health Care*
Designers Jami Ouellette, Mark Bevington

5.
Client *Tick Data*
Designers Mike Domingo, Patrick Dennis

6.
Client *NACCRRA*
Designer David McGaw

7.
Client *Kayrell Solutions*
Designer Kevin Frank
(opposite)
Client *Justin Allen Company*
Design Firm **Ciro Design**
Designer Katrina Luong

THE
Science
FACTORY

1.

2.

Everything
Fun & Fattening!

3.

Whispering Breeze
Dressage

4.

astiva
WORLDWIDE

5.

6.

7.

8.

9.

10.

THE RUSSEL & MARY WILLIAMS LEARNING PROJECT AT PARK TUDOR

11.

12.

13.

14.

15.

1 - 4
Design Firm **j-creative**
5 - 8
Design Firm **LOGOSBRANDS**
9 - 14
Design Firm **Indiana Design Consortium, Inc.**
15
Design Firm **JFDesign**

1.
Client The Science Factory
Designer Joan Gilbert Madsen

2.
Client Think Link Discovery Museum
 for Children
Designer Joan Gilbert Madsen

3.
Client Mad Mary & Company
Designer Joan Gilbert Madsen

4.
Client Whispering Breeze Dressage
Designer Joan Gilbert Madsen

5.
Client Astiva Worldwide
Designers Gabriella Sousa, Brian Smith

6.
Client LOGOSBRANDS
Designers Ali Khan, Sunny Chan

7.
Client LIFE CHOICES Natural Foods
Designers Phil Slous, Franca DiNardo

8.
Client SARDO Food Importers
Designers Ali Khan, Franca DiNardo

9.
Client Lafayette Chamber of Commerce
Designer Andrew R. Schwint

10.
Client Pro Bono
Designer Andrew R. Schwint

11.
Client Park Tudor School
Designer Kristy Blair

12.
Client Elrod Corporation
Designers Andrew R. Schwint,
 Debra Pohl Green

13.
Client Earth Images, Inc.
Designer Andrew R. Schwint

14.
Client Bo-Witt Products, Inc.
Designer Andrew R. Schwint

15.
Client TDU Toys
Designer Josie Fertig

S A N F R A N C I S C O M A R R I O T T

1.

O T O Ñ O
P L A Z A

2.

3.

A

4.

wolner

5.

P

**PRINCETON
METALS**

6.

Leadership | **Communication**

7.

1 - 4
Design Firm **Hornall Anderson Design Works**
5 - 7
Design Firm **Design Matters, Inc!**
1.
 Client *San Francisco Marriott*
 Designers Jack Anderson, Kathy Saito,
 Sonja Max, Alan Copeland,
 Gretchen Cook
2.
 Client *Otoño Plaza*
 Designers John Anicker, Henry Yiu,
 Kathy Saito, Gretchen Cook,
 Sonja Max
3.
 Client *Mulvanny/G2*
 Designers Jack Anderson, Katha Dalton,
 Jana Nishi, Michael Brugman,
 Hillary Radbill, Henry Yiu, Ed Lee
4.
 Client *Hornall Anderson Design Works*
 Designers Jack Anderson, John Hornall,
 Henry Yiu, Andrew Wicklund,
 Mark Popich

5.
 Client *Stephen Z. Wolner, D.D.S.*
 Designers Stephen M. McAllister,
 Gordon Fraser
6.
 Client *Princeton Metal Company*
 Designer Stephen M. McAllister
7.
 Client *Leadership Communication*
 Designers Stephen M. McAllister,
 Gordon Fraser
(opposite)
 Client *Vegewax Candle Worx*
 Design Firm **LOGOSBRANDS**
 Designers Denise Barac, Franca DiNardo

fissure

1.

Judd Allen
G R O U P

2.

 **Mohagen
Hansen**
*Architectural
Group*

3.

 LTRIS

4.

 Integrated Fire Protection

5.

 MemberTrust

6.

Wildfowler
Outfitter

7.

 Property Funding Source

8.

140

9.

1300 HIGHLAND CORPORATE DRIVE

11.

Bennett Embroidery

Custom Apparel for Team & Business

13.

TRACEY GEAR & MACHINE WORKS

10.

12.

elliot's ORIGINAL

ALL NATURAL HOUND SAUCE ®

14.

FIXEL

DIGITAL COLOR +
IMAGE MANIPULATION

15.

1 - 9
Design Firm **Design Center, Inc.**
10 - 15
Design Firm **Creative Vision Design Co.**

1.
Client *Fissure*
Designer Chris Cornejo

2.
Client *Judd Allen Group*
Designer Cory Docken

3.
Client *Mohagen Hansen*
 Architectural Group
Designers Sherwin Schwartzrock,
 Cory Docken

4.
Client *Soltris*
Designer Cory Docken

5.
Client *Integrated Fire Protection*
Designer Cory Docken

6.
Client *MemberTrust*
Designer Sherwin Schwartzrock

7.
Client *WildFowler Outfitter*
Designer Chris Cornejo

8.
Client *Property Funding Source*
Designer Cory Docken

9.
Client *Cade Moore Carpentry*
Designer Sherwin Schwartzrock

10.
Client *Tracey Gear*
Designer Greg Gonsalves

11.
Client *Peregrine Group*
Designer Greg Gonsalves

12.
Client *Graystone Studios*
Designer Greg Gonsalves

13.
Client *Bennett Embroidery*
Designer Greg Gonsalves

14.
Client *S.J. Corio Company*
Designer Greg Gonsalves

15.
Client *Fixel*
Designer Greg Gonsalves

141

1.

2.

3.

4.

5.

6.

mall
205

7.

1 - 7
Design Firm **Dotzero Design**
1.
Client *ALS Association*
Designers Jon Wippich, Karen Wippich
2.
Client *Peddler Bakery*
Designers Jon Wippich, Karen Wippich
3.
Client *National Psoriasis Foundation*
Designers Jon Wippich, Karen Wippich
4.
Client *Healthy Forest*
Designers Jon Wippich, Karen Wippich
5, 6.
Client *Unicru*
Designers Jon Wippich, Karen Wippich

7.
Client *Davis Agency/Mall 205*
Designers Jon Wippich, Karen Wippich
(opposite)
Client Schick Wilkinson Sword
Design Firm **Muts&Joy&Design**
Designer Gisele Sangiovanni

143

Pacific Crest

1.

the Stone Chair

2.

3.

COPY GREEN

4.

Emberland's

5.

BIG SHOT
PICTURES

6.

7.

BRANDYWINE GRAPHICS

8.

9.

10.

11.

12.

13.

14.

15.

1 - 15
Design Firm **Dotzero Design**

1.
Client Pacific Crest Hotel
Designers Jon Wippich, Karen Wippich

2.
Client The Stone Chair
Designers Jon Wippich, Karen Wippich

3.
Client Davis Agency/Griffin Capital
Designers Jon Wippich, Karen Wippich

4.
Client Copy Green
Designers Jon Wippich, Karen Wippich

5.
Client Emberland's
Designers Jon Wippich, Karen Wippich

6.
Client Big Shot Pictures
Designers Jon Wippich, Karen Wippich

7.
Client BIA
Designers Jon Wippich, Karen Wippich

8.
Client Brandywine Graphics
 Silkscreening & Embroidery
Designers Jon Wippich, Karen Wippich

9.
Client OpenAsia
Designers Jon Wippich, Karen Wippich

10.
Client Brandywine Graphics
 Silkscreening & Embroidery
Designers Jon Wippich, Karen Wippich

11.
Client Do It For Peace
Designers Jon Wippich, Karen Wippich

12, 13.
Client Fetish Kings
Designers Jon Wippich, Karen Wippich

14.
Client Unicru
Designers Jon Wippich, Karen Wippich

15.
Client CMD/Bridge Port Brewing Co.
Designers Jon Wippich, Karen Wippich

1.

2.

5.

3.

4.

6.

7.

1 - 7
Design Firm **Greteman Group**
1.
Client *Boise Towne Square*
Designers Sonia Greteman, James Strange,
 Craig Tomson
2.
Client *Oak Creek Mall*
Designers Sonia Greteman, James Strange,
 Craig Tomson
3.
Client *Verus Bank*
Designers Sonia Greteman, James Strange
4.
Client *Kansas State Fair*
Designers Sonia Greteman, James Strange,
 Craig Tomson
5.
Client *Butler College*
Designers Sonia Greteman, James Strange

6.
Client *Cruise Mailing Services*
Designers Sonia Greteman, James Strange
7.
Client *Wichita Festivals*
Designers James Strange, Sonia Greteman
(opposite)
Client Banfi Vintners
Design Firm **Muts&Joy&Design**
Designers Katherine Hames,
 Muts Yasumura

SARTORI
di Verona

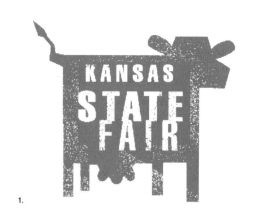

1.

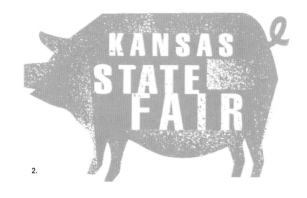

2.

3.

HEALTH
VOYAGE

2003

4.

5.

6.

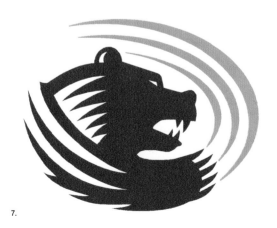

7.

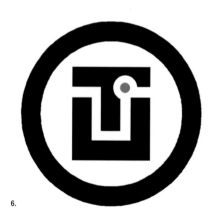

8.

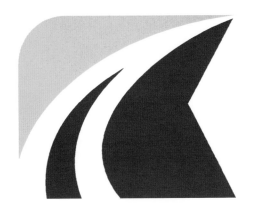

9.

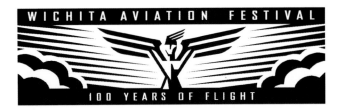

10.

OKLAHOMA TRAILS

11.

12.

13.

14.

15.

1 - 15
Design Firm **Greteman Group**

1, 2.
Client *Kansas State Fair*
Designers Sonia Greteman, James Strange

3.
Client *Kitchen & Bath Gallery*
Designers Sonia Greteman, James Strange

4.
Client *Royal Caribbean Cruises Ltd.*
Designers Sonia Greteman, James Strange

5.
Client *Galichia Heart Hospital*
Designers Sonia Greteman, James Strange

6.
Designers James Strange

7.
Client *Butler College Grizzlies*
Designers Sonia Greteman, James Strange

8.
Client *Out of the Box*
Designers Sonia Greteman, James Strange

9.
Client *Kansas Turnpike Authority*
Designers Sonia Greteman, James Strange

10.
Client *Wichita Aviation Festival*
Designers Sonia Greteman, James Strange

11.
Client *Oklahoma City Zoo*
Designers Sonia Greteman, James Strange

12.
Client *Botanica*
Designers Sonia Greteman, James Strange

13.
Client *Above and Beyond*
Designers Sonia Greteman, James Strange

14.
Client *Strange Ideas*
Designers James Strange

15.
Client *Kansas Humane Society*
Designers Sonia Greteman, James Strange

1.

2.

3.

4.

5.

6.

7.

1 - 7
Design Firm **Greteman Group**

1.
Client *O2 Design*
Designers Sonia Greteman, James Strange

2.
Client *Shawnee Mission Hospital*
Designers Sonia Greteman, James Strange

3.
Client *Kansas Children's Service League*
Designers Sonia Greteman, James Strange

4.
Client *SeaXpress*
Designers Sonia Greteman, James Strange

5.
Client *Greteman Group*
Designers Sonia Greteman, James Strange

6.
Client *Inspiring Leadership*
Designers Sonia Greteman, James Strange

7.
Client *Wichita Festivals*
Designers Sonia Greteman, James Strange

(opposite)
Client *Symphony Importers LLC*
Design Firm **Muts&Joy&Design**
Designers Katherine Hames, Tom Delaney,
 Gisele Sangiovanni

150

1.

2.

3.

4.

5.

6.

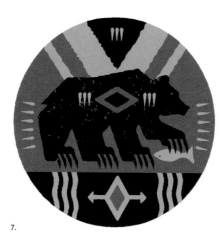

7.

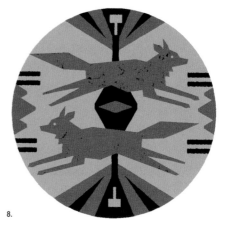

8.

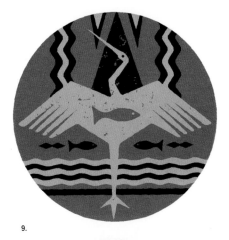

9.

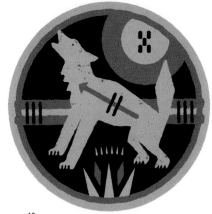

10.

11.

12.

13.

14.

15.

1 - 15
Design Firm **Greteman Group**
1 - 11.
Client *Oklahoma City Zoo*
Designers Sonia Greteman, James Strange
12 - 15.
Client *Royal Caribbean Cruises Ltd.*
Designers Sonia Greteman, James Strange

1.

2.

4.

3.

5.

6.

7.

1
 Design Firm **Greteman Group**
2 - 7
 Design Firm **Insight Design Communications**
1.
 Client *James Strange*
 Designer James Strange
2 - 7.
 Client *The Hayes Co., Inc.*
 Designer Tracy Holdeman

(opposite)
 Client *Centro Cultural*
 E. León Jimenes
 Design Firm **Muts&Joy&Design**
 Designer Katherine Hames

1.

2.

3.

4.

5.

6.

BUZZ
BUILDING
MAINTENANCE

7.

8.

9.

10.

11.

goodgrief
OF KANSAS INC.

12.

13.

14.

15.

1.

2.

3.

4.

BUOY WEAR

Trade Mark

5.

6.

7.

1 - 7
Design Firm **Insight Design Communications**
1.
Client *Floating Swimwear*
Designer Tracy Holdeman
2.
Client *B.G. Automotive Products*
Designer Tracy Holdeman
3.
Client *Anvil Corporation*
Designer Tracy Holdeman
4.
Client *Spangenberg Phillips*
Designer Tracy Holdeman
5.
Client *Floating Swimwear*
Designers Tracy Holdeman, Lea Carmichael
6.
Client *Old Town*
Designer Tracy Holdeman
7.
Client *Carlos O' Kelly's*
Designer Tracy Holdeman

(opposite)
Client *Banco Del Progreso, S.A.*
Design Firm **Muts&Joy&Design**
Designer Gisele Sangiovanni

1.

2.

3.

4.

5.

6.

7.

8.

9.

10.

COLLECTIVECAPACITY™

11.

BOCHNER
Chocolates

12.

no boundaries™

13.

TALASKE

14.

SOUND THINKING™

PELICAN

15.

1 - 5
 Design Firm **Insight Design Communications**
6 - 8
 Design Firm **Keen Branding**
9 - 11
 Design Firm **Exit 33, Inc.**
12 - 15
 Design Firm **Mires>Design for Brands**

1.
 Client *Cedar Creek*
 Designers Tracy Holdeman,
 Lea Carmichael
2.
 Client *Home National Bank*
 Designer Tracy Holdeman
3.
 Client *Land Escape*
 Designer Tracy Holdeman
4.
 Client *Birch*
 Designers Tracy Holdeman,
 Lea Carmichael
5.
 Client *The Hayes Co., Inc.*
 Designer Tracy Holdeman
6.
 Client *Vizuale*
 Designer Mike Raveney

7.
 Client *Act2L Results*
 Designer Mike Raveney
8.
 Client *Attus Technologies*
 Designer Mike Raveney
9.
 Client *McGraw Hill*
 Designer Fodil Seddiki
10.
 Client *Rob Reynolds & Vicki Woodward*
 Designer Fodil Seddiki
11.
 Client *Oliver Smith*
 Designer Fodil Seddiki
12.
 Client *Bochner Chocolates*
 Designers José Serrano, Miguel Perez
13.
 Client *Wal-Mart*
 Designers Scott Mires, Miguel Perez
14.
 Client *Talaske*
 Designers Scott Mires and Neill,
 Leslie Quinn
15.
 Client *Pelican Accessories*
 Designers John Ball, Miguel Perez

PAUL
WU
+
ASSOCIATES
chartered accountants

604,734,7750

1.

Dr. Winnie Su
FAMILY MEDICINE & OBSTETRICS

2.

TWENTY YEARS OF TEAMWORK

3.

THE **VAULT**
A CREATIVE COMMUNITY

4.

SURPRISE
RECREATION CAMPUS

5.

MOMENTUM GROUP

6.

A\\\G
Associated Marketing Group

7.

1, 2
Design Firm **Nancy Wu Design**
3, 4
Design Firm **Iconix, Inc.**
5 - 7
Design Firm **Sullivan Marketing & Communications**

1.
Client *Paul Wu & Associates Ltd.*
Designer Nancy Wu
2.
Client *Dr. Winnie Su, MD*
Designer Nancy Wu
3.
Client *GM/Toyota*
Designer Paul Snyder
4.
Client *Frenak Photo, Inc.*
Designer Marina Savic
5.
Client *City of Surprise AZ*
Designer Jack Sullivan

6.
Client *Momentum Group*
Designer Jack Sullivan
7.
Client *Associated Marketing Group*
Designer Jack Sullivan
(opposite)
Client *Fremont Bank*
Design Firm **Shawver Associates, Inc.**
Designer Amy Krachenfels

FREMONT BANK

163

OI NOITES CARIOCAS

1.

OI NOITES CARIOCAS

2.

OI NOITES CARIOCAS

3.

OI NOITES CARIOCAS

4.

ancine

Agência Nacional
do Cinema

5.

VelaBrasil

6.

concepta

D.G. COMPLIANCE

7.

concepta

D.G. COMPLIANCE

8.

9.

10.

11.

12.

PAPERS

13.

STEPHEN LONGO DESIGN ASSOCIATES

14.

15.

1 - 5
 Design Firm **Pandora**
6 - 9
 Design Firm **Animus Design**
10 - 15
 Design Firm **Stephen Longo + Associates**
1 - 4.
 Client *Oi Noites Cariocas*
 Designers Silvia Grossmann,
 Lauro Machado
5.
 Client *Ancine—National Cinema Agency*
 Designer Silvia Grossmann
6.
 Client *Vela Brasil*
 Designers Marcus Fernandes,
 Rique Nitzche
7, 8.
 Client *Concepta*
 Designers Marcus Fernandes,
 Rique Nitzche
9.
 Client *Manguinhos*
 Designers Aldo Moura,
 Rique Nitzche

10.
 Client *U.S. Parks Service*
 Designer Stephen Longo
11.
 Client *Matsuya Restaurant*
 Designer Stephen Longo
12.
 Client *Nabisco*
 Designer Stephen Longo
13.
 Client *Pop N' Fold Papers*
 Designer Stephen Longo
14.
 Client *Stephen Longo
 Design Associates*
 Designer Stephen Longo
15.
 Client *Township of West Orange*
 Designer Stephen Longo

MAKE **A BETTER PLACE**

1.

NORTHWESTERN NASAL + SINUS

2.

NSX National StockSM Exchange

3.

adatto

4.

fuse

5.

6.

HUBBARD STREET DANCE CHICAGO

7.

1 - 7
Design Firm **Liska + Associates, Inc.**
1.
Client *Make A Better Place*
Designer Fernando Munoz
2.
Client *Northwestern Nasal + Sinus*
Designer Hans Krebs
3.
Client *National Stock Exchange*
Designers Liska + Associates Staff
4.
Client *Adatto*
Designer Jonathan Seeds
5.
Client *Fuse*
Designer Brian Graziano

6.
Client *liquidlibrary*
Designers Liska + Associates Staff
7.
Client *Hubbard Street Dance Chicago*
Designer Steve Liska
(opposite)
Client St. John's University
Design Firm **BrandLogic**
Designers Wynn Medinger,
 Karen Lukas Hardy

st. john's UNIVERSITY

DOUBLEGREEN

LANDSCAPES

1.

emaimai

易買賣

2.

AVENUE Ⓑ

Consulting Inc.

3.

GALLERY C

4.

WESTCHESTER

NEIGHBORHOOD
SCHOOL

5.

dreamlab

6.

[premis]

communications

7.

VISTAMAR

SCHOOL

8.

168

9.

10.

11.

12.

13.

14.

15.

1 - 13
Design Firm **Evenson Design Group**
14, 15
Design Firm **Liska + Associates, Inc.**

1.
Client *Doublegreen Landscapes*
Designer Judy Lee

2.
Client *Emaimai*
Designers Judy Lee, Mark Sojka

3.
Client *Avenue B Consulting Inc.*
Designer Tricia Rauen

4.
Client *Gallery C*
Designer Mark Sojka

5.
Client *Westchester Neighborhood School*
Designers Ken Loh, Ondine Jarl

6.
Client *Honda*
Designers Mark Sojka, John Han

7.
Client *Premis Communications*
Designer Mark Sojka

8.
Client *Vistamar School*
Designer Mark Sojka

9.
Client *Idyllwild Area Historical Society*
Designer Mark Sojka

10.
Client *FirstSpot*
Designer Kera Scott

11.
Client *Warner Bros. Online*
Designer Mark Sojka

12.
Client *Crayola*
Designers Glen Sokamoto, Kera Scott

13.
Client *Move Line*
Designer Mark Sojka

14.
Client *Luxi*
Designer Jonathan Seeds

15.
Client *Lubeznik Center for the Arts*
Designer Laura Litman

1.

2.

3.

4.

5.

6.

7.

1 - 3
Design Firm **McDill Design Milwaukee**
4 - 6
Design Firm **Look Design**
7
Design Firm **Liska + Associates, Inc.**
1.
 Client *Kohler Company*
 Designer Joel Harmeling
2.
 Client *Literacy Services of Wisconsin*
 Designer Brad Bedessem
3.
 Client *Kohler Company*
 Designer Joel Harmeling
4.
 Client *Size Technologies*
 Designers Look Design

5.
 Client *Flex P*
 Designers Look Design
6.
 Client *Ciao Bambino!*
 Designers Look Design
7.
 Client *me&b Maternity*
 Designer Danielle Akstein
(opposite)
 Client *Cubby's Coffee House*
 Design Firm **Evenson Design Group**
 Designer John Krause

1.

2.

3.

4.

5.

6.

7.

8.

9.

10.

11.

12.

13.

14.

15.

1 - 15		
Design Firm	**TD2, S.C. Consultores en Identidad**	
1.		
Client	*A la Medida*	
Designers	Jose Luis Patiño, Rafael Treviño M.	
2.		
Client	*Casa San Matías (Tequila)*	
Designers	R. Rodrigo Córdova, Rafael Treviño M., Adalberto Arenas	
3.		
Client	*CENASA*	
Designer	Rafael Treviño M.	
4 - 7.		
Client	*+KOTA*	
Designers	Rafael Treviño, Erika Bravo	
8.		
Client	*ODM de México*	
Designer	Rafael Treviño M	

9.		
Client	*Omar Monroy*	
Designer	Rafael Rodrigo Córdova	
10.		
Client	*NESTLE Helados*	
Designer	Rafael Rodrigo Córdova	
11.		
Client	*BIMBO*	
Designers	Rafael Treviño M., Rafael Rodrigo Córdova	
12.		
Client	*Nestle Chocolates*	
Designer	Rafael Treviño M.	
13.		
Client	*Nike Mexico*	
Designer	Rafael Treviño M.	
14.		
Client	*Cementos Chihuahua*	
Designer	Rafael Treviño	
15.		
Client	*Mesazón*	
Designers	José Luis Patiño, Rafael Treviño M.	

1.

PL&MB
ASOCIADOS

2.

3.

4.

AEROSPACE RELEASE SYSTEM

5.

Rentalunits.com

6.

bestlodging.com VACANCY

7.

1, 2
 Design Firm TD2, S.C. Consultores en
 Identidad
3
 Design Firm T-1 Productions
4, 5
 Design Firm PhaseOne Marketing & Design
6, 7
 Design Firm Bondepus Graphic Design
1.
 Client Erika Rodriguez
 Designers R. Rodrigo Córdova,
 Miguel Ríos
2.
 Client Juana Pérez
 Designers R. Rodrigo Córdova,
 Sergio Enriquez
3.
 Client Click Zaza
 Designer Parisa Chum

4.
 Client Knoebels Amusement Park
 Designer Michael Tobin
5.
 Client Zyvax, Inc.
 Designer Matthew Korbar
6.
 Client Bestlodging.com
 Designer Gary Epis, Geordie Lynch
7.
 Client Bestlodging.com
 Designers Gary Epis, Amy Bond
(opposite)
 Client Boomerang
 Design Firm Evenson Design Group
 Designer Mark Sojka

174

boomerang™

1.

2.

3.

4.

GALLERY HOMES

A Reich Company

5.

DINNER SOLUTIONS

"it's time to eat."

6.

7.

8.

ulmer | berne | llp
ATTORNEYS

9.

10.

Nature Center
AT SHAKER LAKES

11.

the althans foundation

12.

13.

14.

1.

2.

3.

4.

5.

6.

7.

1, 2
Design Firm **Frank D'Astolfo Design**

3
Design Firm **The Speidell Group**

4
Design Firm **Design Guys**

5
Design Firm **Purdue Student**

6
Design Firm **2g Marketing Communications, Inc.**

7
Design Firm **BBM & D**

1.
Client *UV Solutions Inc.*
Designer Frank D'Astolfo

2.
Client *Tangier American Legation Museum Society*
Designer Frank D'Astolfo

3.
Client *Blue Ridge Potters Guild*
Designer Rebekah E.W. Hoskins

4.
Client *Theatre de la Jeune Lune*
Designers Steven Sikora, Jay Theige

5.
Client *3-2-1 Productions*
Designer Eric Beckner

6.
Client *Queen City Manufacturing*
Designers Ken Adams, Larry Livaudais

7.
Client *Regional Contract Academy Training*
Designers Ari Matson, Jon A. Leslie, Barbara Brown

(opposite)
Client Rocamojo
Design Firm **Evenson Design Group**
Designer Kera Scott

1.

2.

3.

4.

5.

6.

7.

8.

9.

10.

11.

12.

13.

14.

15.

1 - 15
Design Firm **Kenneth Diseño**

1.
Client — Cell Phone & Satellite TV Shop
Designer — Kenneth Treviño

2.
Client — Catarsis Art Gallery
Designers — Kenneth Treviño, Dolores Arroyo

3.
Client — Ixtapa Touristic Map
Designer — Kenneth Treviño

4.
Client — Assoc. of Avocado
Exporters Michoacan
Designer — Kenneth Treviño

5.
Client — Clar Paper Store
Designer — Kenneth Treviño

6.
Client — Delicat Fine Meats & Cheese
Designer — Kenneth Treviño

7.
Client — Hogar Y Ceramica
Designer — Kenneth Treviño

8.
Client — Playeras Michoacanas T Shirts
Designer — Kenneth Treviño

9.
Client — Amimex
Designer — Kenneth Treviño

10.
Client — City of Uruapan Chambers Assoc.
Designer — Kenneth Treviño

11.
Client — Sifrut Avocado Exporters
Designer — Kenneth Treviño

12.
Client — Joy Kids Fun Center
Designer — Kenneth Treviño

13.
Client — Hope For A Better
Future Conference
Designer — Kenneth Treviño

14.
Client — Uruapan City Fair
Designer — Kenneth Treviño

15.
Client — La Guadalupe Nursery
Designer — Kenneth Treviño

1.

2.

corbis®

3.

4.

5.

6.

7.

1
Design Firm **Design Liberation Organisation**
2
Design Firm **Bradfield Design, Inc.**
3
Design Firm **Segura Inc.**
4
Design Firm **Kenji Shimomura**
5
Design Firm **DCG Solutions**
6
Design Firm **Foth & Van Dyke**
7
Design Firm **Becker Design**
1.
Client *Design Liberation Organisation*
Designer Greg Gutbezahl
2.
Client *PAWS/LA*
Designer Debra Bradfield

3.
Client *Corbis*
Designer TNOP
4.
Designer Kenji Shimomura
5.
Client *Copper Care, Inc.*
Designer Marc E. Hedges
6.
Client *Village of Brokaw*
Designer Daniel Green
7.
Client *Twisted Fork Restaurant*
Designer Neil Becker
(opposite)
Client Old Orchard Brande
Design Firm **The Bailey Group**
Designers Steve Perry, Dave Fiedler

1.

2.

3.

4.

5.

6.

7.

8.

9.

10.

11.

12.

13.

14.

15.

1 - 12
Design Firm **Kenneth Diseño**
13 - 15
Design Firm **Garfinkel Design**

1.
Client *Global Frut Avocado Exporters*
Designer Kenneth Treviño

2.
Client *Monroy Panel Factory*
Designer Kenneth Treviño

3.
Client *San Pedro Old Textile Mill*
Designer Kenneth Treviño

4.
Client *Fresh Directions International*
Designer Kenneth Treviño

5, 6.
Client *Fresh Directions Mexicana*
Designer Kenneth Treviño

7.
Client *Monte Azul Housing Development*
Designer Kenneth Treviño

8.
Client *Industrial Mulsa Tequilas*
Designer Kenneth Treviño

9.
Client *Hermanos Gudiño Transport*
Designer Kenneth Treviño

10.
Client *Paulita Day Care Center*
Designer Kenneth Treviño

11.
Client *Turinjandi Hotel-Resort*
Designer Kenneth Treviño

12.
Client *Explora Summer Camp*
Designer Kenneth Treviño

13.
Client *Advanced Wellness Technology*
Designer Wendy Garfinkel-Gold

14.
Client *Garfinkel Design*
Designer Wendy Garfinkel-Gold

15.
Client *Save the Light, Inc.*
Designer Wendy Garfinkel-Gold

1.

2.

3.

4.

5.

6.

7.

1
Design Firm **Addison Whitney**
2
Design Firm **Dean Design/Marketing Group, Inc.**
3
Design Firm **Susan Meshberg Graphic Design**
4, 5
Design Firm **Stan Gellman Graphic Design Inc.**
6, 7
Design Firm **Dotzler Creative Arts**

1.
Client *Brinker International*
Designers Kimberlee Devis, Lisa Johnston, David Houk

2.
Client *Lewes Chamber of Commerce*
Designer Jeff Phillips

3.
Client *Museum of the American Piano*
Designers Susan Meshberg, Michele Kane

4.
Client *Binding Solutions*
Designers Teresa Thompson, Erin Goter

5.
Client *Rosetta Financial Advisors*
Designers David Kendall, Teresa Thompson

6.
Client *Marketplace Vision*
Designers Dotzler Creative Arts

7.
Client *Grace University*
Designers Dotzler Creative Arts

(opposite)
Client Ameristar Casino
Design Firm **Visual Asylum**
Designer Joel Sotelo

1.

2.

3.

4.

5.

6.

7.

8.

9.

10.

11.

12.

13.

14.

15.

1 - 11
Design Firm **Peterson & Company**
12 - 15
Design Firm **Inca Tanvir Advertising LLC**

1.
Client *Dallas Society of Visual Comm.*
Designer Scott Ray

2.
Client *Billy Ray*
Designer Scott Ray

3.
Client *Trophy Dental*
Designer Nhan Pham

4.
Client *MPI Meeting Prof. Int.*
Designer Nhan Pham

5.
Client *George Fox University*
Designer Bryan Peterson

6.
Client *Eagle Materials*
Designer Bryan Peterson

7.
Client *US Dept. of Labor,*
 Womens Bureau
Designer Dorit Suffness

8.
Client *SMU Libraries*
Designer Miler Hung

9.
Client *Simply Placed*
Designer Miler Hung

10.
Client *Liquidity International*
Designer Nhan Pham

11.
Client *Jimmy LaFave,*
 Music Road Records
Designer Scott Ray

12, 13.
Client *United Foods Company (psc)*
Designer Rajan Amrute

14.
Client *Arabian Trading Agency*
Designer Suresh Pawar

15.
Client *India Club, Dubai*
Designer Suresh Pawar

1.

2.

3.

4.

5.

6.

7.

1, 2
 Design Firm **Vince Rini Design**
3, 4
 Design Firm **Baker Brand Communications**
5, 6
 Design Firm **angryporcupine_design**
7
 Design Firm **Seran Design**
1.
 Client *Accu-Stat Diagnostics*
 Designer Vince Rini
2.
 Client *Power Trading USA*
 Designer Vince Rini
3.
 Client *Proximy*
 Designer Melissa Rosen
4.
 Client *Intershore*
 Designer Melissa Rosen

5.
 Client *Arula Systems, Inc.*
 Designer Cheryl Roder-Quill
6.
 Client *Novell, Inc.*
 Designer Cheryl Roder-Quill
7.
 Client *Oasis Gallery*
 Designer Sang Yoon
(opposite)
 Client Pita Products
 Design Firm **Flowdesign, Inc.**
 Designer Dan Matauch

1.

2.

3.

3.

4.

5.

6.

7.

8.

9.

ANKENY

10.

11.

12.

13.

Full House Gaming

14.

15.

Laura **Chwirut**

1.

KAREN
ONG

2.

junghee hahm

3.

Boston ★ 2004
Nothing conventional about it.

4.

Bariatric Surgery Center
BAXTER REGIONAL MEDICAL CENTER

5.

Articulate
FINE ART PUBLISHING

6.

Design North

7.

1
Design Firm **Laura Chwirut**
2
Design Firm **Karen Ong**
3
Design Firm **Junghee Hahm Design**
4
Design Firm **Hill Holliday**
5
Design Firm **Brooks-Jeffrey Marketing, Inc.**
6
Design Firm **Robert Meyers Design**
7
Design Firm **Design North, Inc.**

1.
Client *Laura Chwirut*
Designer Laura Chwirut
2.
Client *Karen Ong*
Designer Karen Ong

3.
Client *Junghee Hahm*
Designer Junghee Hahm
4.
Client *Democratic National Convention*
Designer Vic Ceroli, Sean Westgate
5.
Client *Bariatric Surgery Center*
 Baxter Regional Medical Center
Designers Brooks-Jeffrey Marketing
 Creative Team
6.
Client *Articulate*
Designer Robert Meyers
7.
Client *Design North, Inc.*
(opposite)
Client Xango
Design Firm **Flowdesign, Inc.**
Designer Dan Matauch

1.

2.

3.

4.

5.

6.

7.

8.

Cuyahoga Valley

HI-Stanford Hostel

9.

Cuyahoga Valley

Scenic Railroad

10.

Cuyahoga Valley

National Park

11.

Cuyahoga Valley

National Park Association

12.

Cuyahoga Valley

Countryside Conservancy

13.

14.

15.

1 - 15
Design Firm **Herip Design Associates, Inc.**
1 - 8.
Client *Cleveland Indians*
Designers Walter M. Herip,
 John R. Menter
9 - 13.
Client *Cuyahoga Valley National Park*
Designers Walter M. Herip,
 John R. Menter
14.
Client *The Fudge Sisters*
Designer Walter M. Herip
15.
Client *The Richard E. Jacobs Group, Inc.*
Designers Walter M. Herip,
 John R. Menter

1.

2.

3.

4.

5.

6.

7.

1, 2
Design Firm **Fassino/Design**
3, 4
Design Firm **RS+K**
5, 6
Design Firm **Pear Design**
7
Design Firm **Walsh Design**

1.
Client *FoldRx*
Designers Chris Connors,
 Diane Fassino
2.
Client *Versal Entertainment*
Designer Angela Nannini
3.
Client *RS+K*
Designer Scot Kemp
4.
Client *Venture Investors*
Designer Kathleen Mitchell-Abendroth

5.
Client *Digitalhub*
Designers Linda Jackson,
 Norbert Marszalek
6.
Client *Pear Design*
Designers Linda Jackson,
 Norbert Marszalek
7.
Client *Rözana Cuizine*
Designers Miriam Lisco,
 Cathy Burnell
(opposite)
Client ISI International
Design Firm **Walsh Design**
Designers Miriam Lisco,
 Andrew MacDonald

PACIFIC DRAGON

PACIFIC DRAGON

Tail-Off Farm Raised
BLACK TIGER SHRIMP

Cooked • Peeled & Deveined • Ready to Eat

HACCP Serving Suggestion
Enlarged to Show Quality

Net. W...
(2L...

PACIFIC DRAGON

Farm Raised Uncooked
BLACK TIGER SHRIMP

Shell-On • Ready to Cook

HACCP Serving Suggestion
Enlarged to Show Quality

Net. Wt. 32 OZ.
(2Lbs) 907g

1.

2.

3.

BRACE
YOURSELF

4.

5.

6.

7.

8.

9.

10.

11.

12.

13.

LAND CAPITAL
FINANCIAL

14.

15.

1 - 15
Design Firm **M3AD.com**

1.
| Client | Chronos 3 |
| Designers | Dan McElhattan III, Lauren M. Brown |

2.
| Client | Chronos 3 |
| Designer | Dan McElhattan III |

3.
| Client | Brace Yourself |
| Designers | Dan McElhattan III, Raymond Perez |

4.
| Client | Attitude Clothier |
| Designer | Dan McElhattan III |

5.
| Client | Navegante Group, Evolution |
| Designers | Dan McElhattan III, Raymond Perez |

6.
| Client | dm design lab |
| Designer | Dan McElhattan III |

7.
| Client | Paramount Professional Plaza |
| Designer | Dan McElhattan III |

8.
| Client | Elisa Cooper, Mark Monitor |
| Designer | Dan McElhattan III |

9.
| Client | M3 Advertising Design |
| Designer | Dan McElhattan III |

10.
| Client | Pentacore Engineering |
| Designer | Dan McElhattan III |

11.
| Client | Eco Style |
| Designer | Dan McElhattan III |

12.
| Client | Primm Investments |
| Designer | Dan McElhattan III |

13.
| Client | Land Baron Investments |
| Designer | Dan McElhattan III |

14.
| Client | Land Capital Financial |
| Designer | Dan McElhattan III |

15.
| Client | Luttrell Associates |
| Designer | Dan McElhattan III |

1.

2.

C·A·M

CRANE ASSET MANAGEMENT, LLC

3.

STUDIO G

4.

HOMEGROWN
KIDS

5.

6.

7.

1
Design Firm **Development Design Group, Inc.**
2
Design Firm **Crendo**
3
Design Firm **Bloch + Coulter Design Group**
4
Design Firm **Studio G**
5, 6
Design Firm **Vince Rini Design**
7
Design Firm **GOLD & Associates, Inc.**

1.
Client *The Ellman Companies*
Designer Valerie Cataffa
2.
Client *Extandon Inc.*
Designer Tamra Heathershaw-Hart

3.
Client *Crane Asset Management LLC*
Designer Ellie Young Suh
4.
Client *Studio G*
Designer Gretchen Wills
5.
Client *Homegrown Kids*
Designer Vince Rini
6.
Client *Freedom Business Brokers*
Designer Vince Rini
7.
Client *Florida Folk Festival*
Designers Keith Gold, Peter Butcavage
(opposite)
Client *Good Humor-Breyers*
Design Firm **Smith Design**
Designer Carol Konkowski

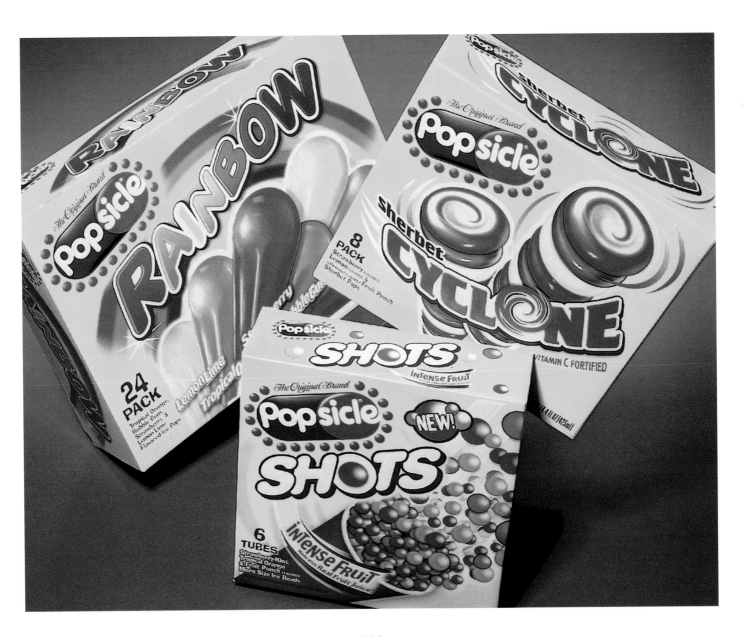

MAGNUMOPUS

1.

mindy l.frank

bp

balanceplus

2.

BLEU

GOURMET

3.

Just Imagine
INDUSTRIES

4.

C H R N O S

5.

M³

M

M3 ADVERTISING DESIGN

6.

LIFE OR **DEATH**
L E A D E R S H I P

7.

florence barnhart

8.

Jeanne Goodrich
C O N S U L T I N G

9.

Tell Me A Story...

10.

VERB | creative

11.

BLACKSTONE

12.

EPIPHANY ROAD

MUSIC

13.

PHOTON Light.com

14.

Paradise

MEDIA

15.

1 - 6
Design Firm **M3AD.com**
7 - 15
Design Firm **Defteling Design**

1.
Client *MagnuMOpus*
Designers Dan McElhattan III,
David Araujo

2.
Client *Balance Plus*
Designer Dan McElhattan III

3.
Client *Sonny Ahuja*
Designers Dan McElhattan ,
David Araujo

4.
Client *Just Imagine Industries*
Designer Dan McElhattan III

5, 6.
Client *M3 Advertising Design*
Designer Dan McElhattan

7.
Client *Life or Death Leadership*
Designer Alex Wijnen

8.
Client *Florence Barnhart*
Designer Alex Wijnen

9.
Client *Jeanne Goodrich Consulting*
Designer Alex Wijnen

10.
Client *Tell Me A Story*
Designer Alex Wijnen

11.
Client *Verb Creative*
Designer Alex Wijnen

12.
Client *Blackstone, Inc.*
Designer Alex Wijnen

13.
Client *Epiphany Road Music*
Designer Alex Wijnen

14.
Client *Photon Light*
Designer Alex Wijnen

15.
Client *Paradise Media, Inc.*
Designer Alex Wijnen

1.

2.

3.

4.

Cranial Capital SM

5.

6.

7.

1
 Design Firm **Defteling Design**
2, 3
 Design Firm **Herip Design Associates, Inc.**
4
 Design Firm **GOLD & Associates, Inc.**
5, 6
 Design Firm **Icon Graphics Inc.**
7
 Design Firm **Lesniewicz Associates**
1.
 Client *Union Point Custom Feeds*
 Designer Alex Wijnen
2, 3.
 Client *The Richard E. Jacobs Group, Inc.*
 Designers Walter M. Herip, John R. Menter
4.
 Client *Fast Olive*
 Designer Jan Hanak

5.
 Client *Cranial Capital, LLC*
 Designers Icon Graphics Inc.
6.
 Client *Perinton Youth Hockey*
 Designers Icon Graphics Inc.
7.
 Client *Roach Graphics*
 Designer Terry Lesniewicz
(opposite)
 Client *Food Collage, Inc.*
 Design Firm **Flowdesign, Inc.**
 Designer Dan Matauch

206

1.

2.

3.

4.

5.

6.

7.

stepxstep

8.

208

9.

Erie　Bleu

10. Alpaca Farm

Alliance Venture Mortgage

11.

12.

ShapesSTUDIO™

13.

14.

15.

1 - 15
Design Firm **Lesniewicz Associates**

1.
Client　Indigo Market Ltd.
Designer　Jack Bollinger

2.
Client　Java Hut
Designer　Jack Bollinger

3.
Client　Microsoft
Designer　Terry Lesniewicz

4.
Client　Schmakel Dentistry
Designer　Les Adams

5.
Client　Preview Home Inspection
Designers　Amy Lesniewicz,
　　　　　Terry Lesniewicz

6.
Client　Owens Corning
Designer　Jack Bollinger

7.
Client　Toledo Public Schools
Designer　Les Adams

8.
Client　Step By Step
Designer　Terry Lesniewicz

9.
Client　Duket, Porter MacPherson
Designer　Les Adams

10.
Client　Erie Bleu Alpaca Farm
Designer　Amy Lesniewicz

11.
Client　Alliance Venture Mortgage
Designer　Amy Lesniewicz

12.
Client　Graebel Companies, Inc.
Designer　Les Adams

13.
Client　Shapes Studio
Designer　Terry Lesniewicz

14.
Client　Golden Retriever
　　　　Rescue of Michigan
Designer　Amy Lesniewicz

15.
Client　Financial Design Group
Designer　Jack Bollinger

1.

2.

RSNA'03

COMMUNICATION FOR
3. BETTER PATIENT CARE

4.

5.

6.

7.

1 - 4
Design Firm **Asylum Strategic Design**
5 - 7
Design Firm **Beth Singer Design, LLC**

1.
Client *Plano*
Designers Bill Current, Ron Klein
2.
Client *Radiological*
Designers Ron Klein, Bill Current
3.
Client *Radiological*
Designers Jay Vidheecharoen, Ron Klein
4.
Client *Alafia*
Designers Dave Bruck, Bill Current

5.
Client *The International Commission on
 Holocaust Era Insurance Claims*
Designer Chris Hoch
6.
Client *Classic Poker*
Designers Sucha Snidvongs,
 Steve Trapero
7.
Client *B'nai B'rith Youth Organization*
Designers Suheun Yu, Chris Hoch
(opposite)
Client *Tom McIlhenny*
Design Firm **Performance Graphics
 of Lake Norman, Inc.**
Designer Mitzi Mayhew

1.

2.

3.

4.

5.

6.

7.

8.

CONCERN:EAP

Better business from balanced lives

9.

efficēon ™

10.

Transmeta
CORPORATION

11.

aftermedia ®

12.

BETA BREAKERS
SOFTWARE QUALITY ASSURANCE LABS

13.

SIX DEGREES

14.

ACADEMY STUDIOS

15.

1.

GL✺BAL
IMPACT

2.

3.

SAVORY FLAVOR
MOSAIC

4.

flavors for kids

5.

MARIN
EDUCATION
FUND

Creating Educational Equity

6.

1 - 3
 Design Firm **TGD Communications**
4, 5
 Design Firm **AJF Marketing**
6, 7
 Design Firm **Ann Hill Communications**
1.
 Client *Association of Government
 Accountants*
 Designer Jennifer Cedoz
2.
 Client *Global Impact*
 Designer Gloria Vestal
3.
 Client *Centennial Contractors Enterprises*
 Designer Gloria Vestal

4.
 Client *IFF-International Flavors
 & Fragrances*
 Designer Justin Brindisi
5.
 Client *IFF-International Flavors
 & Fragrances*
 Designer Paul Borkowski
6.
 Client *Marin Education Fund*
 Designer Jack Zoog
7.
 Client *College of Marin Foundation*
 Designer Jack Zoog
(opposite)
 Client *21st Century Spirits*
 Design Firm **Flowdesign, Inc.**
 Designer Dan Matauch

COLLEGE OF MARIN
FOUNDATION

7.

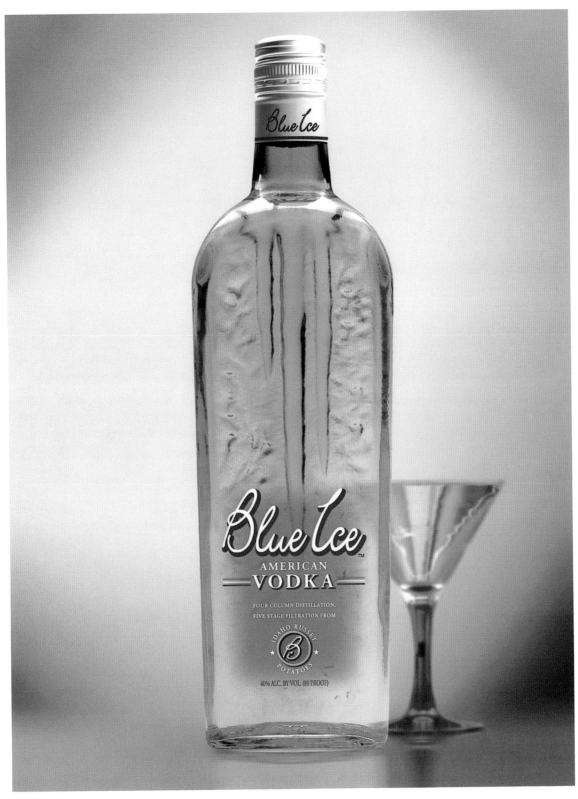

1.

OceanParkHotels

2.

3.

Capitol ™

4.

BLACKLAKE
GOLF RESORT

5.

6.

7.

FOSSIL CREEK

8.

216

BED & BREAKFAST

9.

SAN LUIS OBISPO

ASSOCIATES

A Medical Group, Inc.

10.

11.

12.

DANISH VILLAGE

13.

14.

15.

1 - 15
Design Firm **Pierre Rademaker Design**

1.
Client *Martin Resorts*
Designers Debbie Shibata, Pierre Rademaker

2.
Client *Ocean Park Hotels*
Designers Anne Bussone, Pierre Rademaker

3.
Client *Moonstone Hotel Properties*
Designers Debbie Shibata, Pierre Rademaker

4.
Client *Capitol Outdoor*
Designers Anne Bussone, Pierre Rademaker

5.
Client *Infinite Horizon's*
Designers Debbie Shibata, Pierre Rademaker

6.
Client *Martin & Hobbs*
Designers Anne Bussone, Sierra Slade,
 Pierre Rademaker

7.
Client *Martin Resorts*
Designers Pierre Rademaker, Debbie Shibata

8.
Client *Fossil Creek Winery*
Designers Anne Bussone, Pierre Rademaker

9.
Client *Petite Soleil*
Designers Anne Bussone, Pierre Rademaker

10.
Client *San Luis Obispo Eye Associates*
Designers Kenny B. Swete, Dusty Davis,
 Pierre Rademaker

11.
Client *San Luis Railroad Museum*
Designers Elisa York, Anne Bussone,
 Pierre Rademaker

12.
Client *San Luis Obispo*
Designer Pierre Rademaker

13.
Client *Solvang*
Designers Pierre Rademaker, Debbie Shibata

14.
Client *The Sea Barn*
Designers Elisa York, Pierre Rademaker,
 Debbie Shibata

15.
Client *Moonstone Hotel Properties*
Designers Pierre Rademaker, Debbie Shibata

1.

2.

3.

4.

5.

6.

7.

1, 2
Design Firm **Medialias Creative**
3 - 5
Design Firm **Levine & Associates**
6, 7
Design Firm **Zoe Graphics**

1.
Client *Cold Water Imports*
Designers Gregg Holda,
 Shaun Menestrina
2.
Client *Rockfish Boardwalk Bar & Sea Grill*
Designers Gregg Holda,
 Shaun Menestrina
3.
Client *Kellogg Foundation*
Designer Lena Markley
4.
Client *Garfinkel + Associates*
Designer Jennie Jariel

5.
Client *United Brotherhood of*
 Carpenters & Joiners of America
Designer Steve Ofner
6.
Client *St. Francis Medical Ctr.*
Designers Kim Waters, Kathy Pagano
7.
Client *Digital Brand Expressions*
Designers Kim Waters, Kathy Pagano
(opposite)
Client *American Beverage Marketers*
Design Firm **Flowdesign, Inc.**
Designer Dan Matauch

218

A DECADE OF DISCOVERIES

1.

eyePhysicians™

2.

)ESIGN (OMMAND (ENTER

3.

4.

DEAL OF A LIFETIME

5.

6.

YO PHILLY BLOCK PARTY

7.

8.

9.

10.

The Forum of
Executive Women

11.

SKYLINE
TERRACE

12.

13.

WEsT EnD

CITY APARTMENTS

14.

15.

1 - 13
 Design Firm **The STAR Group**
14, 15
 Design Firm **Skidmore Inc.**
1.
 Client *Garden State Discovery Museum*
 Designer Dave Girgenti
2.
 Client *Eye Physicians*
 Designer Dave Girgenti
3.
 Client *Design Command Center*
 Designer Dave Girgenti
4.
 Client *Pennsylvania University*
 Designer Dave Girgenti

5 - 7.
 Client *Trump Marina*
 Designer Dave Girgenti
8 - 10.
 Client *Blue Chip Casino*
 Designer Dave Girgenti
11.
 Client *The Forum For Executive Women*
 Designer Dave Girgenti
12, 13.
 Client *Charles Town Races & Slots*
 Designer Dave Girgenti
14, 15.
 Client *Village Green Companies*
 Designer Pete Nothstein

1.

University
Book Store

2.

WASHINGTON DC SEPTEMBER 11, 2001
Memorial Groves

3.

Be well.

Ride your bike.

4.

BLANK

5.

Geac™

6.

7.

1, 2
Design Firm **Hornall Anderson Design Works**
3 - 5
Design Firm **Blank Inc.**
6, 7
Design Firm **Hull Creative Group**

1.
Client *Solavie*
Designers Jack Anderson, Kathy Saito,
 Gretchen Cook, Sonja Max,
 Henry Yiu, Alan Copeland
2.
Client *University Book Store*
Designers John Hornall, Mary Hermes,
 Belinda Bowling, Holly Craven
3.
Client *Greenspaces for DC*
Designers Danielle Willis, Robert Kent Wilson

4.
Client *League of American Bicyclists*
Designers Robert Kent Wilson,
 Jay Kokernak,
 Christine Dzieciolowski
5.
Client *Blank Inc.*
Designers Robert Kent Wilson,
 Christine Dzieciolowski
6.
Client *Geac Corporation*
Designer Amy Braddock
7.
Client *Inmagic Corporation*
Designer Carolyn Colonna
(opposite)
Client *Oliver Winery*
Design Firm **Flowdesign, Inc.**
Designer Dan Matauch

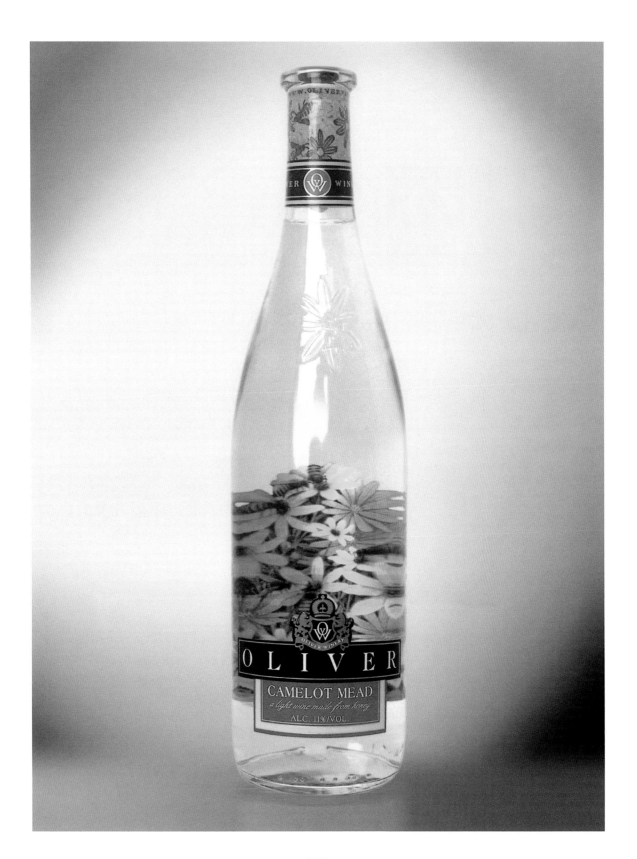

1.

2.

Chicago Avenue Evanston

3.

4.

PREMIER FINANCIAL COMPANIES

5.

6.

7.

8.

cards & gifts

9.

10.

11.

12.

focus

Fitness Center

13.

SHADES

14.

15.

1.

2.

KWIK DATA SYSTEMS

3.

Greater Jamaica
Development
Corporation

4.

SUMMIT

5.

AZIA
center
汇亚大厦

6.

7.

1 - 3
Design Firm **imagineGrafx**
4 - 6
Design Firm **Calori & Vanden-Eynden**
7
Design Firm **FUSZION Collaborative**

1.
Client *South Valley Christian Church*
Designer Stephen Guy

2.
Client *Church Sports Int'l*
Designer Stephen Guy

3.
Client *KWIK Data Systems*
Designer Stephen Guy

4.
Client *Greater Jamaica Development*
 Corporation
Designers David Vanden-Eynden,
 Marisa Schulman

5.
Client *City of Summit, NJ*
Designers David Vanden-Eynden,
 Denise Funaro-Psoinos

6.
Client *Shanghai Investment*
 Real Estate Development
Designers David Vanden-Eynden,
 Chris Calori,
 Lindsay McCosh,
 Marisa Schulman

7.
Client *uReach.com*
Designer Steve Dreyer
(opposite)
Client *Morinda, Inc.*
Design Firm **Flowdesign, Inc.**
Designer Dan Matauch

FUSZION | COLLABORATIVE

1.

2.

3.

5.

REALSHOW

4.

DECO THERAPY

6.

PALETTE

8.

CREATIVE
MINDFLOW

7.

9.

Austrian Ceramics and Industrial Minerals

10.

11.

12.

viterma

ich fühl mich wohl.

13.

ARCUTERM

14.

15.

1 - 8
Design Firm **FUSZION Collaborative**

9 - 15
Design Firm **motterdesign**

1.
Client *FUSZION Collaborative*
Designers Tony Fletcher, Rick Heffner

2.
Client *Smith Fellows*
Designer John Foster

3.
Client *Community Anti-Drug Coalitions of America*
Designer John Foster

4.
Client *Art Director's Club of Metropolitan Washington*
Designer John Foster

5.
Client *Americans for the Arts*
Designer John Foster

6.
Client *Deco Therapy*
Designers Steve Dreyer, Rick Heffner

7.
Client *Creative Mindflow*
Designer Christian Baldo

8.
Client *Palette Restaurant*
Designers Tony Fletcher, Rick Heffner

9.
Client *Frewein & Farr*
Designer Siegmund Motter

10.
Client *Aucerma*
Designer Siegmund Motter

11.
Client *Unitec*
Designer Siegmund Motter

12.
Client *Ö-Bad**
Designer Siegmund Motter

13.
Client *Viterma*
Designer Siegmund Motter

14.
Client *Arcuterm*
Designer Siegmund Motter

15.
Client *Holzmüller*
Designer Siegmund Motter

COUNCIL FOR LOGISTICS RESEARCH, INC.

1.

2.

3.

4.

5.

6.

7.

1 - 3
 Design Firm **MDVC Creative, Inc.**
4 - 7
 Design Firm **Martin-Schaffer, Inc.**
1.
 Client *Council for Logistics
 Research, Inc.*
2.
 Client *Mitsui Bussan Logistics*
3.
 Client *On Computer Services*
4.
 Client *Grace Vydac*
 Designers Steve Cohn,
 Tina Martin

5.
 Client *TakeCharge Technologies*
 Designers Kelly Mathieu,
 Tina Martin
6, 7.
 Client *Grace Vydac*
 Designers Steve Cohn,
 Tina Martin
(opposite)
 Client *Fuze Candy*
 Design Firm **Out Of The Box**
 Designer Rick Schneider

Köhnlein Messtechnik

1.

KAPPLER

Bäder zum Leben

2.

KAPP

ROHRREINIGUNG
ABFLUSSRETTUNGSDIENST

3.

EBINGER ED DETT

4.

eigen werk !

5.

Ramah Wagner
business of health

6.

FAHRSCHULE
RÜDINGER

7.

RAINER SCHANZ

8.

STERNEN
FEUER

9.

müller|instrumente

10.

KERN

11.

MCHENRY
BOWL

12.

CITY OF MODESTO
OPERATIONS &
MAINTENANCE

13.

14.

15.

1 - 11
Design Firm **revoLUZion**
 Advertising and Design
12 - 15
Design Firm **Never Boring Design Associates**

1.
 Client *KMT Köhnlein Messtechnik*
 Designer **Bernd Luz**
2.
 Client *Kappler*
 Designer **Bernd Luz**
3.
 Client *Kapp*
 Designer **Bernd Luz**
4.
 Client *Ebinger Dett*
 Designer **Bernd Luz**
5.
 Client *Eigenwerk*
 Designer **Bernd Luz**
6.
 Client *Ramah Wagner*
 Designer **Bernd Luz**

7.
 Client *Fahrschule Rüdinger*
 Designer **Bernd Luz**
8.
 Client *Rainer Schanz*
 Designer **Bernd Luz**
9.
 Client *Verena Plein*
 Designer **Bernd Luz**
10.
 Client *Müller Instrumente*
 Designer **Bernd Luz**
11.
 Client *Kern Keto Design*
 Designer **Bernd Luz**
12.
 Client *McHenry Bowl*
 Designer **Dyle Stoddard**
13.
 Client *City of Modesto*
 Designer **Dyle Stoddard**
14.
 Client *State Theatre*
 Designer **Dyle Stoddard**
15.
 Client *Ooohlala*
 Designer **Cheryl Cernigoj**

1.

2.

3.

4.

5.

6.

roche salon

www.rochesalon.com

7.

1, 2
Design Firm **Michael Lee
Advertising & Design, Inc.**
3, 4
Design Firm **Mark Oliver, Inc.**
5, 6
Design Firm **Redpoint Design**
7
Design Firm **Lomangino Studio, Inc.**

1.
Client *Coastal Welding Supply*
Designers Michael Lee,
Debby Stasinopoulou
2.
Client *Matagorda Yacht Club*
Designers Michael Lee,
Debby Stasinopoulou
3.
Client *Ocean Beauty Seafoods*
Designers Mark Oliver, Harry Bates

4.
Client *Ocean Beauty Seafoods*
Designers Mark Oliver, Tom Hennessy
5.
Client *Kidtricity*
Designers Clark Most,
Ty Smith
6.
Client *Heart Design*
Designer Clark Most
7.
Client *Roche Salon*
Designer Kristina Bonner
(opposite)
Client *Firenze Bread Co.*
Design Firm **Pandora**
Designer Silvia Grossman

HOME FORGE

REMODELING, INC.

1.

HOME FORGE
REMODELING, INC.

2.

clean edge

3.

ed
clean
ge

4.

ALVAR

5.

6.

7.

WALTON
REGIONAL MEDICAL CENTER

8.

9.

10.

11.

12.

13.

14.

15.

1 - 15
Design Firm **WorldSTAR Design**

1, 2.
Client *Home Forge Remodeling, Inc.*
Designer Greg Guhl

3, 4.
Client *Clean Edge*
 Domestic Services, Inc.
Designer Greg Guhl

5.
Client *Decorative Expressions, Inc.*
Designer Greg Guhl

6.
Client *Contingency*
 Management Group, LLC
Designer Greg Guhl

7.
Client *American Heart Association*
Designer Greg Guhl

8.
Client *Walton Regional*
 Medical Center
Designer Greg Guhl

9.
Client *Georgia Hospital Association*
Designer Greg Guhl

10.
Client *U.S. Environmental Services, Inc.*
Designer Greg Guhl

11.
Client *The Specialty Hospital*
Designer Greg Guhl

12.
Client *WellStar Health System*
Designer Greg Guhl

13 - 15.
Client *Georgia Hospital Association*
Designer Greg Guhl

1.

2.

3.

4.

TCN WORLDWIDE

5.

6.

7.

1 - 3
Design Firm **Grizzell & Co.**
4 - 6
Design Firm **Lambert Design**
7
Design Firm **WorldSTAR Design**
1 - 3.
Client *MLP*
Designer John H. Grizzell
4.
Client *Access HDTV*
Designer Amy Sharp
5.
Client *TCN Worldwide*
Designer Christie Lambert

6.
Client *TechLife Styles*
Designer Christie Lambert
7.
Client *Georgia Hospital Association*
Designer Greg Guhl
(opposite)
Client *Dr. Temt Laboratories
 (Cosmetics)*
Design Firm **designbuero**
Designer Thomas Stockhammer

go**4**elements

1.

2.

3.

4.

5.

6.

7.

8.

INK JET & COLOR LASER PAPERS

9.

10.

11.

LemonAid Crutches

12.

 EAGLE HILL

ΛCCESSCOMPLIANCE™
A CFM Partners Program

13.

14.

 formtek

15.

1.

2.

3.

5.

6.

7.

1 - 7
Design Firm **InGEAR**
1.
 Client *Meijer*
 Designer Matt Hassler
2.
 Client *Target*
 Designer Matt Hassler
3.
 Client *Kmart*
 Designer Matt Hassler
4.
 Client *InGEAR Corporation*
 Designer Kurt Lichte

5, 6.
 Client *JC Penney*
 Designer Matt Hassler
7.
 Client *The Sports Authority*
 Designer Matt Hassler
(opposite)
 Client *Sony Computer*
 Entertainment America
 Design Firm **CDI Studios**
 Designer Eddie Roberts

 Exploration Ltd.

1.

Creative Differences

2.

Integrius Solutions
Integration, Integrity, Intelligence

3.

E2E

Entrepreneur to Entrepreneur

4.

molecular pr
Business Connection and Public Awareness Builders

5.

Vision Exploration Inc.

6.

THOUSAND OAKS

ARTS FESTIVAL

7.

Morningstar Farms

8.

9.

10.

11.

12.

THERMA

T E C H

13.

14.

15.

1 - 6
Design Firm **Gabriella Sousa Designs**
7 - 12
Design Firm **DuPuis**
13 - 15
Design Firm **InGEAR**

1.
Client *Emnak Exploration Ltd.*
Designer Gabriella Sousa
2.
Client *Creative Differences*
Designers Gabriella Sousa, Anne Sinclair
3.
Client *Integrius Solutions*
4.
Client *The Enterprise Centre*
Designer Gabriella Sousa
5.
Client *Molecular pr*
Designers Gabriella Sousa, Laurie Campbell
6.
Client *Vision Exploration Inc.*
Designer Gabriella Sousa
7.
Client *Thousand Oaks Civic Arts Plaza*
Designers Bill Corridori, Al Nanakonpanom

8.
Client *Kelloggs Morningstar Farms*
Designers Steven DuPuis, Bill Pierce
9.
Client *Keebler*
Designers Steven DuPuis, Bill Pierce
10.
Client *Foster Farms*
Designers Steven DuPuis, John Silva
11.
Client *Kelloggs Fruit Twistables*
Designers Steven Dupuis,
Al Nanakonpanom,
John Silva, John Poll,
Lindsay Evans
12.
Client *Kelloggs Pop Tarts*
Designers Steven DuPuis, Bill Pierce
Damon Thompson
13.
Client *InGEAR*
Designer Jeremy Swanson
14, 15.
Client *Mass Merchants/Consumer*
Designer Derek Crenshaw

245

1.

THE STORY OF GOD'S
PROMISE FOR ALL PEOPLE

2.

TREES UNLIMITED

3.

SECOND
BAPTIST
CHURCH

4.

Integrated Electrical Services

5.

FISHER, BOYD, BROWN
BOUDREAUX & HUGUENARD LLP

6.

ATTORNEYS AT LAW

THE
TEXAN
TWO
STEP

7.

1 - 7
Design Firm **Loucks Designworks**
1.
 Client *Stein Group*
 Designer Jay Loucks
2.
 Client *Mars Hill Productions*
 Designer Jay Loucks
3.
 Client *Trees Unlimited*
 Designer Jay Loucks
4.
 Client *Second Baptist Church*
 Designer Jay Loucks

5.
 Client *Integrated Electrical Services*
 Designer Jay Loucks
6.
 Client *Fisher Boyd*
 Designer Jay Loucks
7.
 Client *Ronald McDonald
 House of Houston*
 Designer Jay Loucks
(opposite)
 Client *Tumak's Bar & Grill*
 Design Firm **CDI Studios**
 Designer Eddie Roberts

DOMINION

POST OAK

1.

firstbank

2.

isolagen

The Science of Living Cells

3.

FifthWard
Pregnancy
HelpCenter

4.

Environmental
Achievement
Award

Schering-Plough

5.

rivet inc.

6.

RED OAK
CONSULTING

A DIVISION OF MALCOLM PIRNIE

7.

FLM Graphics

8.

elucient

9.

dse | b®andesign

10.

T O S C A N A

ON GRACE BAY

11.

Con Edison *Communications*

12.

InfraMetrix℠

INFRASTRUCTURE DIAGNOSTIC SERVICES

13.

trilogy

14.

PATCHAM

15.

1 - 4
Design Firm **Loucks Designworks**
5 - 14
Design Firm **Design Source East**
15
Design Firm **T-1 Productions**

1.
Client — *Dominion Post Oak*
Designer — Jay Loucks

2.
Client — *First Federal Bank, Texas*
Designer — Jay Loucks

3.
Client — *Isolagen*
Designer — Jay Loucks

4.
Client — *Fifth Ward Pregnancy*
Designer — Jay Loucks

5.
Client — *Schering-Plough*
Designer — H. Dean Pillion

6.
Client — *Rivet Inc.*
Designer — Mark Lo Bello

7.
Client — *Red Oak Consulting*
Designer — Mark Lo Bello

8.
Client — *FLM Graphics Corporation*
Designer — Mark Lo Bello

9.
Client — *elucient*
Designer — Mark Lo Bello

10.
Client — *Design Source East*
Designer — Mark Lo Bello

11.
Client — *Toscana USA, LLC*
Designer — Mark Lo Bello

12.
Client — *Con Edison Communications*
Designers — Mark Lo Bello, H. Dean Pillion

13.
Client — *InfraMetrix*
Designer — Mark Lo Bello

14.
Client — *Trilogy Publications LLC*
Designer — Mark Lo Bello

15.
Client — *Patcham Chemicals*
Designer — Parisa Chum

Pope John Paul II
HIGH SCHOOL

1.

MUSIC GROUP

2.

FR◦ST
SPECIALTY RISK

3.

Stick Buddy®

4.

THE DESIGN ACADEMY

5.

interiors·R·US

6.

D-TRAN

7.

1 - 4
Design Firm **Ventress Design Group**
5 - 7
Design Firm **T-1 Productions**
1.
 Client *Pope John Paul II High School*
 Designer Tom Ventress
2.
 Client *The Magnet Music Group*
 Designer Tom Ventress
3.
 Client *Frost Specialty Risk*
 Designer Tom Ventress

4.
 Client *T.A.C.K. Inc.*
 Designer Tom Ventress
5.
 Client *The Design Academy*
 Designers Pallav Patel, Parisa Chum
6.
 Client *Interiors R Us*
 Designers Parisa Chum, Pallav Patel
7.
 Client *D-TRAN.com*
 Designer Pallav Patel
(opposite)
 Client *Ambiance design group*
 Design Firm **CDI Studios**
 Designer Michelle Georgilas

AMBIANCE design group*

1.

2.

3.

4.

5.

6.

7.

8.

9.

Autoridad de Acueductos y Alcantarillados

10.

11.

FUNDACIÓN COMUNITARIA
DE PUERTO RICO

12.

COOPERATIVA DE
SEGUROS MULTIPLES
DE PUERTO RICO

13.

iicom
INSTITUTO DE
INGENIEROS DE
COMPUTADORAS

14.

15.

1 - 8
Design Firm **Graco Inc.**
9 - 15
Design Firm **ID Group**

1.
Client *Contractor Division*
Designer Todd Safgren
2.
Client *Contractor Division*
Designer David Orwoll
3 - 7.
Client *Industrial Division*
Designer Gary Schmidt
8.
Client *Corporate*
Designer Gary Schmidt
9.
Client *PeeWee's Grill*
Designers Carolina Carezis,
Abner Gutiertuez

10.
Client *Autoridad de Acueductos y Alcantarillados*
Designers Jorge Colon,
Abner Gutierrez
11.
Client *Punto Aparte Publicidad*
Designers Sofiá Saenz,
Abner Gutierrez
12.
Client *Fundacion Comunitaria De PR*
Designer Mayra Maldonado
13.
Client *Cooperativa Seguros Multiples PR*
Designers Mayra Maldonado,
Abner Gutierrez
14.
Client *Instituto Ingenieros De Computadoras*
Designer Mayra Maldonado
15.
Client *Tres Monjitas Dairy*
Designers Abner Gutierrez,
Mayra Maldonado

TRES MONJITAS

Design Firm **ID Group**
Client *Tres Monjitas Dairy*
Designers Abner Gutierrez,
Mayra Maldonado

ANCHOR
BRAND

ATS LABS
EXCELLENCE IN ANTIMICROBIAL TESTING

2.

REGENCYSM
BEAUTY INSTITUTE

3.

NaturNorth
Technologies™

innovative solutions from nature

4.

★ MIND ★
MATTERS

ALL CHILDREN
CAN LEARN

5.

OLD TOWN
TEA CO.

6.

enforme
INTERACTIVE

7.

8.

STRUT YOUR STUFF
Displays & Exhibits

9.

Home Crest
Insurance Services, Inc.

10.

The
First Page

11.

12.

www.taxhomme.com

13.

medicalalumni association

14.

15.

1. ignite ESSENTIALS

2.

TD @it

IT's different here.™

3.

S STUTT KITCHENS & FINE CABINETRY

4.

skule alumni

5.

ORGANIZATIONAL MOMENTUM

6.

mesh innovations

7.

1 - 7
Design Firm **Provoq Inc.**
1.
Client *Ignite Essentials Leadership Development*
Designer Jeffrey Chow
2.
Client *The Gallanough Resource Centre*
Designer Jeffrey Chow
3.
Client *TD Bank Financial Group*
Designer Jeffrey Chow
4.
Client *Stutt Kitchens & Fine Cabinetry*
Designer Jeffrey Chow

5.
Client *University of Toronto Engineering Alumni Association*
Designer Jeffrey Chow
6.
Client *Organizational Momentum*
Designer Jeffrey Chow
7.
Client *Mesh Innovations Inc.*
Designer Jeffrey Chow
(opposite)
Client *Sony Computer Entertainment America*
Design Firm **CDI Studios**
Designer Eddie Roberts

icon style guide

To maintain the CHOC brand image, any icon created and used to represent the hospital or its affiliates follows the same visual style as that established by the masterbrand signature, the mascot, and the affiliate icons. The examples below show various icons created for use in conjunction with newsletters and other collateral materials. Their shared characteristics include energetic, gestural pen strokes and simplified graphic treatments. Extend this same illustrative style when creating new iconic artwork.

CHOC Institute

CHOC Foundation
for Children

Kids Health: Calendar

Literacy

Physician Connection Logo

P.C: CME Lectures/Dinners

P.C: This & That

P.C: Case Study

P.C: Welcome

15

choc affiliates

ICON USAGE

Our affiliates are fund-raising groups that support our organization and are an integral part of CHOC. Each has an icon that visually ties into the brand image. These icons are used to represent Guild activities that promote our hospital. It is important that these icons be used with as much respect and care as the CHOC Mascot. Like the mascot, these icons may be cropped and screened in their specified color, as long as they maintain their unique characteristics and recognizability. Be sure to leave a clear space of at least ¹/₂" around each icon when used as a logo. Each icon prints in one color, using the specified color, in black, or reversed to white.

Mad Hatter Guild
PMS 347

Small World Guild
PMS 660

Little Red Wagon Guild
PMS 200

Littlest Angel Guild
PMS 310

Lamp Lighter Guild
PMS 129

Jack & Jill Guild
PMS 660

Mother Goose Guild
PMS 200

11

Design Firm **Hornall Anderson Design Works**
Client *CHOC (Children's Hospital of Orange County)*
Designers Jack Anderson, Lisa Cerveny, Debra McCloskey, Steffanie Lorig, Jana Wilson Esser, Gretchen Cook, Jana Nishi, Darlin Gray

261

AIMCO

1.

evolution

sports & music

2.

SoftPro
2004
USER GROUP
conference

3.

SoftPro
CORPORATION

2003
user group conference

4.

3 v CAPITAL

5.

MONTAGGIO

european style for the american lifestyle

6.

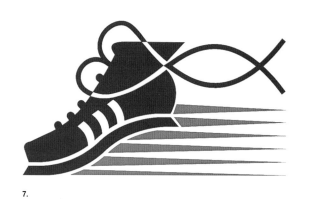

7.

1 - 4
 Design Firm **CAI Communications**
5, 6
 Design Firm **OrangeSeed Design**
7
 Design Firm **Rickabaugh Graphics**
1.
 Client *Key Risk*
 Designer Steve McCulloch
2.
 Client *Evolution Technologies*
 Designer Beth Greene
3, 4.
 Client *SoftPro*
 Designer Beth Greene

5.
 Client *3v Capital*
 Designers Damien Wolf, Phil Hoch
6.
 Client *Montaggio*
 Designers Damien Wolf, Phil Hoch
7.
 Client *Run for Christ*
 Designer Eric Rickabaugh
(opposite)
 Client *AIGA Las Vegas*
 Design Firm **CDI Studios**
 Designers Michelle Georgilas,
 MacKenzie Walsh

1.

2.

3.

4.

NyGUARD™
Breaking the Cycle™

5.

RIPT!DE™

6.

MIDTOWN EXCHANGE

UNITY • COMMUNITY • OPPORTUNITY

7.

LAKESHORE GRILL

8.

9.

10.

11.

12.

13.

CENTER ROKODELSTVA LJUBLJANA

14.

15.

1 - 6
Design Firm **OrangeSeed Design**
7 - 12
Design Firm **Shea, Inc.**
13 - 15
Design Firm **KROG**
1, 2.
 Client *OrangeSeed Design*
 Designer Damien Wolf
3 - 6.
 Client *McLaughlin Gormley King Company*
 Designers Damien Wolf, Phil Hoch
7.
 Client *Ryan Companies*
 Designer Jason Wittwer
8.
 Client *Marshall Fields*
 Designers Michele Leitner, Mark Whitenack

9.
 Client *Stacks/American Retrospect Inc.*
 Designer Jason Wittwer
10 - 12.
 Client *Historic Theatre District*
 Designers James Rahn, Viera Hartmanova
13.
 Client *Obrtna zbornica Slovenije, Ljubljana*
 Designer Edi Berk
14.
 Client *Center rokodelstva Ljubljana*
 Designer Edi Berk
15.
 Client *Vodovod-Kanalizacija, Ljubljana*
 Designer Edi Berk

265

Sport Squirt ™

1.

Flexo Impressions, Inc.

2.

EQUITY
BANK

3.

DIGITAL EDISON
a multimedia developer

4.

BRS
Defining Aviation Safety ™

5.

San Diego Trust
BANK

6.

7.

1 - 5
Design Firm **Hendler-Johnston**
6, 7
Design Firm **Crouch and Naegeli/**
Design Group West
1.
Client *Sport Squirt*
Designer Chris Hendler
2.
Client *Flexo Impressions, Inc.*
Designer Chris Hendler
3.
Client *Equity Bank*
Designer Chris Hendler

4.
Client *Digital Edison*
Designer Chris Hendler
5.
Client *BRS*
Designer Chris Hendler
6.
Client *San Diego Trust Bank*
Designer Jim Naegeli
7.
Client *Asteres*
Designer Jim Naegeli
(opposite)
Client *Project Sunshine*
Design Firm **CDI Studios**
Designer Michelle Georgilas

RED HOT 02'

Gersh Hospitality Group

1.

2.

3.

水 WATER

4.

Willow Creek
WELLNESS

5.

advantix

6.

Venus™

7.

NECKY KAYAKS

8.

9.

10.

11.

 stressdesign

12.

Unwin Development
Support for Public Broadcasting

13.

14.

15.

1.

2.

3.

4.

5.

6.

7.

1 - 3
Design Firm **Crouch and Naegeli/
Design Group West**
4 - 7
Design Firm **Dan Liew Design**
1.
Client *Vaudit*
Designer Jim Naegeli
2.
Client *Vuit*
Designer Jim Naegeli
3.
Client *Winds*
Designers Megan Boyer,
 Jim Naegeli
4.
Client *California Care Staffing*
Designers Dan Liew, Chris Ardito

5.
Client *Marin Child Abuse
 Prevention Center*
Designer Dan Liew
6.
Client *Marin Advocates for Children*
Designer Dan Liew
7.
Client *OnCommand*
Designers Dan Liew, Phorest Bateson
(opposite)
Client *Sony Computer
 Entertainment America*
Design Firm **CDI Studios**
Designer Eddie Roberts

1.

Life Is For the Taking

2.

**GLOBAL CARE
STAFFING**

3.

4.

Impresa Ardita

5.

6.

net-medix

7.

8. SITESCAPES

ibrain

9.

10.

Z
zaphers®

11.

WORLD
WASH
WASH & FOLD • ALTERATIONS

12.

13.

On Your Side

14.

PAX
CERAMICA

15.

1 - 8
Design Firm **Dan Liew Design**

9 - 15
Design Firm **Mitten Design**

1.
Client — *Margurite Holloway*
Designer — Dan Liew

2.
Client — *Lift*
Designers — Dan Liew, Chris Ardito

3.
Client — *Global Care Staffing*
Designers — Dan Liew, Chris Ardito

4.
Client — *BatchMakers*
Designer — Dan Liew

5.
Client — *Chris Ardito/Impresa Ardita*
Designers — Dan Liew, Chris Ardito

6.
Client — *Valhalla Restaurant*
Designers — Dan Liew, Linda Kelly, Jet Lim

7.
Client — *Net Medix*
Designers — Dan Liew, Chris Ardito

8.
Client — *Sitescapes*
Designers — Dan Liew, Linda Kelly

9.
Client — *Ibrain, Inc.*
Designer — Marianne Mitten

10.
Client — *City Frame*
Designer — Marianne Mitten

11.
Client — *Hingston Consulting Group*
Designers — Marianne Mitten, Audrey Dufresne

12.
Client — *World Wash*
Designers — Marianne Mitten, Audrey Dufresne

13.
Client — *Schwab Institutional*
Designer — Marianne Mitten

14.
Client — *On Your Side*
Designers — Marianne Mitten, Baykal Askar

15.
Client — *Pax Ceramica*
Designer — Marianne Mitten

1.
The Cata*lyst* Group, Inc.

2.
strong™

cpi™
260

3.

Circle
BANK

4.

5
FIVEPOINT
CREDIT UNION

tki™

6.

mbti™

7.

1
　Design Firm **Mitten Design**
2 - 7
　Design Firm **Mortensen Design Inc.**
1.
　Client　　*The Catalyst Group*
　Designer　Marianne Mitten
2, 3.
　Client　　*CPP Inc.*
　Designers　Helena Seo,
　　　　　　Gordon Mortensen
4.
　Client　　*Circle Bank*
　Designers　Ann Jordan,
　　　　　　Gordon Mortensen

5.
　Client　　*FivePoint Credit Union*
　Designers　Helena Seo,
　　　　　　Gordon Mortensen
6, 7.
　Client　　*Cpp Inc.*
　Designers　Helena Seo,
　　　　　　Gordon Mortensen
(opposite)
　Client　　*Sony Computer*
　　　　　　Entertainment America
　Design Firm **CDI Studios**
　Designers　Eddie Roberts,
　　　　　　Casey Corcoran

THE ROOSEVELT INVESTMENT GROUP

1.

MICHAEL RUBIN
ARCHITECTS

2.

MAYFLOWER
NATIONAL
LIFE INSURANCE CO.

3.

DIRTWORKS, PC

LANDSCAPE ARCHITECTURE

4.

CREW CONSTRUCTION

5.

6.

DOCUMENT SECURITY
SYSTEMS INC.

7.

8.

276

9.

HERON HILL

10.

Rapidac
Machine Corporation®

11.

12.

13.

14.

GLOBAL LIQUIDS TEAM

15.

1 - 5
Design Firm **Acme Communications, Inc.**

6 - 11
Design Firm **McElveney & Palozzi Design Group Inc.**

12 - 15
Design Firm **Tom Fowler, Inc.**

1.
Client *The Roosevelt Investment Group*
Designers Kiki Boucher, Jon Livingston

2.
Client *Michael Rubin Architects*
Designer Kiki Boucher

3.
Client *Mayflower National Life Insurance Co.*
Designers Andrea Ross Boyle, Kiki Boucher

4.
Client *Dirtworks, PC*
Designers Kiki Boucher, Jon Livingston

5.
Client *Crew Construction Corp.*
Designer Kiki Boucher

6.
Client *McElveney & Palozzi Design Group Inc.*
Designers Gloria Kreitzberg, Steve Palozzi, William McElveney

7.
Client *Document Security Systems Inc.*
Designers William McElveney, Lisa Gates

8.
Client *Bausch & Lomb*
Designer Steve Palozzi

9.
Client *Gravure Magazine*
Designers William McElveney, Lisa Gates

10.
Client *Heron Hill Winery*
Designers Steve Palozzi, William McElveney

11.
Client *Rapidac Machine Corporation*
Designers Matt Nowicki, Lisa Gates

12.
Client *CPS Communications*
Designer Thomas G. Fowler

13.
Client *Inua Gallery*
Designer Thomas G. Fowler

14.
Client *Table to Table*
Designer Thomas G. Fowler

15.
Client *Unilever HPC NA*
Designers Mary Ellen Butkus, Jennifer Lipsett

1.

2.

3.

4.

Northamerican
Financial
Corporation

5.

6.

7.

1
 Design Firm **Karen Skunta & Company**
2
 Design Firm **Kellum McClain Inc.**
3 - 5
 Design Firm **McGaughy Design**
6, 7
 Design Firm **Tom Fowler, Inc.**
1.
 Client *Smith International*
 Designers Karen A. Skunta,
 Christopher Suster,
 Barbara Chin
2.
 Client *Primedia*
 Designers Beverly McClain,
 Ron Kellum

3.
 Client *McGaughy Design*
 Designer Malcolm McGaughy
4.
 Client *Carole Goeas*
 Designer Malcolm McGaughy
5.
 Client *Northamerican Financial Corp*
 Designers McGaughy Design
6.
 Client *Gideon Cardozo
 Communications*
 Designer Thomas G. Fowler
7.
 Client *Agos Bar and Restaurant*
 Designer Thomas G. Fowler
(opposite)
 Client *Westwood Studios*
 Design Firm **CDI Studios**
 Designer Victoria Hart

278

1.

2.

3.

4.

5.

6.

Give Something Back
International

EDUCATION TO CHANGE LIVES

7.

8.

BAY AREA
AIR QUALITY
MANAGEMENT
DISTRICT

9.

TelePLACE

10.

QUALYS 2003 SECURITY CONFERENCE

SECURITY
ON DEMAND

11.

motion

12.

13.

14.

15.

1 - 6
 Design Firm **LPG Design**
7 - 15
 Design Firm **Gee + Chung Design**
1.
 Client *B-H Innovations*
 Designer *Dustin Commer*
2, 3.
 Client *Burke Enterprise*
 Designer *Dustin Commer*
4.
 Client *Har-son Inc.*
 Designer *Dustin Commer*
5.
 Client *International Coleman
 Collectors Club Inc.*
 Designer *Dustin Commer*
6.
 Client *Love Packaging Group*
 Designer *Rick Gimlin*

7.
 Client *Give Something Back
 International Foundation*
 Designer *Earl Gee*
8.
 Client *RWI Group, LLP*
 Designer *Earl Gee*
9.
 Client *Bay Area Air Quality
 Management District*
 Designer *Earl Gee*
10.
 Client *TelePlace*
 Designer *Earl Gee*
11.
 Client *Qualys, Inc.*
 Designer *Earl Gee*
12.
 Client *3-D Motion*
 Designer *Fani Chung*
13 - 15.
 Client *Nanocosm Technologies, Inc.*
 Designer *Fani Chung*

1.

2.

3.

4.

5.

6.

7.

1 - 7
Design Firm **Sayles Graphic Design, Inc.**
1.
 Client *Blue Crab Lounge*
 Designer John Sayles
2.
 Client *308 Martini Bar*
 Designer John Sayles
3.
 Client *B-Flat Music*
 Designer John Sayles
4.
 Client *MetroJam*
 Designer John Sayles
5.
 Client *Meredith Corporation*
 Designer John Sayles

6.
 Client *Home Connection*
 Designer John Sayles
7.
 Client *Backburner Grille and Cafe*
 Designer John Sayles
(opposite)
 Client *Westwood Studios*
 Design Firm **CDI Studios**
 Designer Victoria Hart

282

The corporate logo can be reversed out (appear all in white) of a virtually unlimited variety of bold and bright background colors. The key is to make sure there is adequate contrast between the logo and background. Background options range from our corporate colors (shown here) to Pantone cool and warm grays, four and darker, to any other color with appropriate contrast. Steer clear of pale, washed out, and neutral background colors.

A	HS BLUE (100%)	B	HS GREEN (100%)
C	HS YELLOW (100%)	D	BLACK (100%)
E	PANTONE COOL GRAY 4 (100%) AND DARKER		
F	PANTONE WARM GRAY 4 (100%) AND DARKER		

7/99 DATE OF LAST REVISIONS TO WHOLE DOCUMENT
7/99 DATE OF LAST REVISIONS TO THIS PAGE

1.10

Design Firm **Mortensen Design**
Client *Handspring*
Designers Gorden Mortensen,
 PJ Nidecker

A good background treatment can make the corporate symbol and/or signature pop off the page. After testing scores of options, we've determined the symbol is most compelling against a white background. If white isn't appropriate, Pantone's cool gray colors—one through eight—provide a complementary contrast without overshadowing the dynamics of the symbol. Use the following sample treatments to get a feel for effective background color usage.

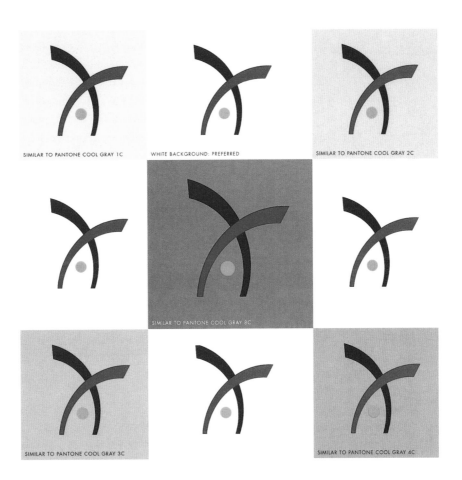

SIMILAR TO PANTONE COOL GRAY 1C

WHITE BACKGROUND: PREFERRED

SIMILAR TO PANTONE COOL GRAY 2C

SIMILAR TO PANTONE COOL GRAY 8C

SIMILAR TO PANTONE COOL GRAY 3C

SIMILAR TO PANTONE COOL GRAY 4C

1.

2.

3.

4.

5.

6.

7.

1 - 4
Design Firm **Sonalysts, Inc.**
5, 6
Design Firm **Sayles Graphic Design, Inc.**
7
Design Firm **Ukulele Brand Consultants Pte Ltd**

1.
Client *Southern Auto Auction*
Designers Stephen Freitas, Rob King, Carol Hoyem, Rena DeBortoli

2.
Client *Todd English's Tuscany*
Designers Kathee Speranza-Ryan, Tracy Sainte Marie, John Visgilio

3.
Client *Mohegan Sun*
Designers Kathee Speranza-Ryan, Shannon Brenek, John Visgilio

4.
Client *Intrawest*
Designers Mike Skiles, Tracy Sainte Marie, John Visgilio

5.
Client *Well-Oiled Machine*
Designer John Sayles

6.
Client *WoodCraft Architectural Millwork*
Designer John Sayles

7.
Client *Yeo Hiap Seng (Singapore) Pte Ltd*
Designers Kim Chun-wei, Cheng Tze Tzuen

(opposite)
Client *Herbal Philosophy Pte Ltd*
Design Firm **Ukulele Brand Consultants Pte Ltd**
Designers Kim Chun-wei, Yvonne Lee

teaspa™

1.

ONE FORT

2.

yungwah

3.

n e x u s

Connecting Ideas

4.

SGXLink

5.

6.

KAWISERAYA
CORPORATION

7.

worldgreen

8.

288

lipico

9.

PEOPLE CONNECT

10.

FRANKFURT LOCKT!
KIRCHENTAG 2001

11.

fly it

12.

ERACON

13.

GRS Batterien

14.

ROLAND
SCHERBARTH
HAIRSTYLING

15.

1 - 9
Design Firm **Ukulele Brand Consultants Pte Ltd**

10 - 15
Design Firm **Aufgeweckte Werbung**

1.
Client *Yeo Hiap Seng (Singapore) Pte Ltd*
Designers Kim Chun-wei, Stephanie Tan

2.
Client *Chip Eng Seng Corporation Ltd*
Designers Kim Chun-wei, Cheng Tze Tzuen

3.
Client *Yung Wah Industrial Co. (Pte) Ltd*
Designers Kim Chun-wei, Jessica Ang

4.
Client *Ministry of Manpower*
Designers Kim Chun-wei, Jessica Ang

5.
Client *Singapore Exchange*
Designers Kim Chun-wei, Yvonne Lee

6.
Client *Office Libre Pte Ltd*
Designers Kim Chun-wei, Kok Yu Kim

7.
Client *Kawiseraya Corporation*
Designers Kim Chun-wei, Daphne Chan

8.
Client *Worldgreen Pte Ltd*
Designers Kim Chun-wei, Lynn Lim

9.
Client *Lipico Technologies Pte Ltd*
Designers Kim Chun-wei, Cheng Tze Tzuen

10.
Client *People-Connect*
Designer Georg Hahn, Fout Simbolico

11.
Client *Sound of Frankfurt*
Designer Georg Hahn, Thomas Maritsdike

12.
Client *fly-it*
Designers Georg Hahn, Sonja Bader

13.
Client *Eracon*
Designer Georg Hahn

14.
Client *GRS*
Designer Georg Hahn

15.
Client *Roland Scherbarth*
Designer Georg Hahn

1.

2. Ruffin' It

3.

4.

5.

6.

7.

1, 2
 Design Firm **Designs on You!**
3
 Design Firm **Aufgeweckte Werbung**
4 - 7
 Design Firm **Visual Asylum**
1.
 Client *Rx Express*
 Designers Suzanna Stephens,
 Anthony B. Stephens
2.
 Client *Ruffin' It*
 Designers Anthony B. Stephens,
 Suzanna Stephens
3.
 Client *die Schnittstelle*
 Designer George Hahn

4 - 7.
 Client *Ameristar Casinos*
 Designer Joel Sotelo
(opposite)
 Client *O-Ton*
 Design Firm **Aufgeweckte Werbung**
 Designer Georg Hahn

1. OPER
 in die Schule!

2. British Travel Company

3. PREMA

MICHAEL JORDAN

CELEBRITY
INVITATIONAL
5.

SUNBURST
BUFFET
7.

4. LEFFINGWELLS

PEGASUS
RACE & SPORTS BOOK
6.

8.

ULTRA

NIGHT
CLUB

9.

10.

11.

12.

13.

15.

SINGAPORE
SPORTS SCHOOL

1.

2.

uPside
dOWn
umbrella

3.

marketing
REÑOVATION

4.

bondepus
GRAPHIC
DESIGN

5.

J&B PROPERTIES

6.

7.

1
Design Firm **Ukulele Brand Consultants Pte Ltd**
2
Design Firm **Aufgeweckte Werbung**
3, 4
Design Firm **Visual Asylum**
5 - 7
Design Firm **Bondepus Graphic Design**
1.
Client *Singapore Sports School*
Designers Kim Chun-wei,
Cheng Tze Tzuen
2.
Client *ZVEI (Zentralverband Elektrotechnik und Elektronikindustrie*
Designer Georg Hahn
3.
Client *Upside Down Umbrella*
Designers Visual Asylum

4.
Client *Meg Joseph*
Designer Long Lé
5.
Client *Bondepus Graphic Design*
Designers Gary Epis, Amy Bond
6.
Client *J+B Properties*
Designers Gary Epis, Amy Bond
7.
Client *DIVA Sports*
Designers Gary Epis, Amy Bond
(opposite)
Client *Protegrity Incorporated*
Design Firm **Resendesign**
Designer Ken Resen

Design Firm **Sky Design**
Client City Of Chamblee, Ga.
Designers W. Todd Vaught,
Carrie Brown

ANTERO RESOURCES
1.

M E D I A
F U R N I T U R E
2.

ΛPEX
DERMATOLOGY
3.
GROUP

ExtendedPresence
Outsourced Sales Professionals
4.

Montessori Academy of Colorado
5.

AMERICA
AND THE WORLD
6.

e**Board**®
7.

1 - 7
Design Firm **Convexus Consulting, Inc.**
1.
Client *Antero Resources*
Designers Karl Peters,
David Warren
2.
Client *Media Furniture*
Designer Karl Peters
3.
Client *Apex Dermatology Group*
Designers Karl Peters,
David Warren
4.
Client *Extended Presence*
Designers Karl Peters,
David Warren
5.
Client *Montessori Academy of Colorado*
Designers Karl Peters,
David Warren

6.
Client *America and the World*
Designers Karl Peters,
David Warren
7.
Client *eBoard.com*
Designer Karl Peters
(opposite)
Client *Aga Khan Foundation USA*
Design Firm **Poonja Design, Inc.**
Designer Suleman Poonja

PartnershipWalk

 NeededNumbers

1.

 Convexus

2.

3.

4.

5.

 Lions klub Ljubljana Iliria ILIRIA

6.

 RUSTIKA

7.

 VINSKA KRALJICA SLOVENIJE

8.

9.

101
ZAKLAD

10.

Perger
·1·7·5·7·

11.

12.

13.

14.

LITTERA·SCRIPTA·MANET

15.

1, 2		
Design Firm	**Convexus Consulting, Inc.**	
3 - 15		
Design Firm	**KROG**	
1.		
	Client	Optima Marketing
	Designer	Karl Peters
2.		
	Client	Convexus Consulting, Inc.
	Designers	Karl Peters, David Warren
3, 4.		
	Client	Presernova druzba, Ljubljana
	Designer	Edi Berk
5.		
	Client	Mladinska knjiga, Ljubljana
	Designer	Edi Berk
6.		
	Client	Lions klub Ljubljana Iliria
	Designer	Edi Berk
7.		
	Client	Janko in Zdena Mlakar, Ljubljana
	Designer	Edi Berk
8.		
	Client	Pomurski sejem, Gornja Radgona
	Designer	Edi Berk

9.		
	Client	Ministry of Agriculture of the Republic of Slovenia, Ljubljana
	Designer	Edi Berk
10.		
	Client	Kmecki glas, Ljubljana
	Designer	Edi Berk
11.		
	Client	Hrabroslav Perger, Slovenj Gradec
	Designer	Edi Berk
12.		
	Client	Pravna fakulteta, Ljubljana
	Designer	Edi Berk
13.		
	Client	Andrej Mlakar, Ljubljana
	Designer	Edi Berk
14.		
	Client	Grupa X, Ljubljana
	Designer	Edi Berk
15.		
	Client	Pravna fakulteta, Ljubljana
	Designer	Edi Berk

1.

2.

3.

4.

5.

6.

7.

1
Design Firm **KROG**
2 - 4
Design Firm **Bondepus Graphic Design**
5
Design Firm **Studio Rayolux**
6
Design Firm **Vitro Robertson**
7
Design Firm **Roni Hicks & Associates**

1.
Client — *Grafika Paradoks, Ljubljana*
Designer — Edi Berk
2.
Client — *Michael K. De Neve & Co*
Designers — Gary Epis, Amy Bond
3.
Client — *Barbagelata Construction*
Designers — Gary Epis, Amy Bond

4.
Client — *SKOV Construction*
Designers — Gary Epis, Amy Bond
5.
Client — *International Snow Leopard Trust*
Designer — Thad Boss
6.
Client — *Yamaha Watercraft*
Designers — Tracy Sabin, Mike Brower
7.
Client — *Sterling on the Lake*
Designers — Tracy Sabin, Stephen Sharp
(opposite)
Client — *Innovative Foods Corp.*
Design Firm **LOGOSBRANDS**
Designers — Denise Barac,
Franca Di Nardo

olive gold™ MC

premium margarine supérieure
Low in Saturated Fat • Non-Hydrogenated
Faible en gras saturés • Non hydrogénée
Made with Extra Light Flavoured Olive Oil
Faite avec de l'huile d'olive extra-légère aromatisée

COR DAIRY/LAITIER

2 lb • 907 g

olive gold™

premium margarine
Low in Saturated Fat
Non-Hydrogenated

INGREDIENTS: CANOLA OIL AND EXTRA LIGHT OLIVE OIL 69.5%, WATER 16%, MODIFIED PALM OIL 10.5%, SALT 1.8%, WHEY POWDER 1.4%, VEGETABLE MONO AND DIGLYCERIDES 0.4%, SOY LECITHIN 0.2%, POTASSIUM SORBATE 0.1%, ARTIFICIAL FLAVOUR, ALPHA TOCOPHEROL, VITAMIN A PALMITATE, VITAMIN D3, BETA CAROTENE, CITRIC ACID. KEEP REFRIGERATED. GOOD FOR COOKING AND BAKING. ONE ASPECT OF A HEALTHY DIET IS TO HAVE NOT MORE THAN 10% OF ENERGY FROM SATURATED FAT.

1.

2.

3.

4.

5.

6.

7.

8.

PeerBridge

9.

10.

New Center
for ARTS *and* CULTURE

11.

12.

Taralon

13.

Clifton Heights
LA COSTA OAKS

14.

15.

1 - 4
 Design Firm **Parker/White**
5 - 12
 Design Firm **Gill Fishman Associates**
13, 14
 Design Firm **Roni Hicks & Associates**
15
 Design Firm **Sabingrafik, Inc.**
1 - 4.
 Client *Centerpulse*
 Designers Tracy Sabin, Dylan Jones
5.
 Client *Harvard VES*
 Designer Alicia Ozyjowski
6.
 Client *Mass Software Council*
 Designers Alicia Ozyjowski,
 Michael Persons
7.
 Client *Bit9 Inc.*
 Designer Alicia Ozyjowski

8.
 Client *Crystal Lake Camps*
 Designer Michael Persons
9.
 Client *Peerbridge Group*
 Designer Michael Persons
10.
 Client *Brown University*
 Designer Gill Fishman
11.
 Client *New Jewish Center for Arts*
 Designer Alicia Ozyjowski
12.
 Client *Trine Pharmaceuticals*
13.
 Client *Taralon*
 Designers Tracy Sabin, Stephen Sharp
14.
 Client *Clifton Heights*
 Designers Tracy Sabin, Stephen Sharp
15.
 Client *San Pacifico*
 Designer Tracy Sabin

1.

2.

3.

4.

5.

6.

7.

8.

306

9.

10.

11.

12.

14.

15.

1 - 15
Design Firm **Rickabaugh Graphics**
1 - 4.
 Client *The Ohio State University*
 Designers Eric Rickabaugh, Dave Cap
5 - 7.
 Client *The Big East Conference*
 Designers Eric Rickabaugh, Rob Carolla
8.
 Client *Hasbro, Inc.*
 Designers Bill Concannon, Dave Cap
9.
 Client *Atlanta Knights*
 Designers Eric Rickabaugh, Mike Linley

10.
 Client *Coca-Cola/Momentum*
 Designers Nathan Forness, Eric Rickabaugh
11.
 Client *University of Dayton*
 Designer Eric Rickabaugh
12, 13.
 Client *The Ball Busters*
 Designer Eric Rickabaugh
14, 15.
 Client *Seton Hall University*
 Designers Eric Rickabaugh, Dave Cap

1.

2.

3.

4.

5.

6.

Northern California Investments

7.

1 - 3
Design Firm **Rickabaugh Graphics**
4 - 7
Design Firm **Steven Lee Design**
1 - 3.
Client *Defiance College*
Designer Eric Rickabaugh
4.
Client *SNIPS*
Designer Steven Lee
5.
Client *Safety Awareness for Everyone*
Designer Steven Lee
6.
Client *Prime Pacific Global
 Management Corporation*
Designer Steven Lee

7.
Client *Northern California Investments*
Designer Steven Lee
(opposite)
Client *Saint John's Health Center*
Design Firm **Poonja Design, Inc.**
Designer Suleman Poonja

JIMMY STEWART

RELAY MARATHON

2001

1.

2.

3.

4.

5.

6.

7.

8.

STANDARD VISION CARE SDN BHD

9.

TCL PLASTIC INDUSTRIES SDN. BHD.

10.

11.

Lingkaran Unik
DEVELOPMENT SDN BHD

12.

PLANO-COMP

13.

RESTORAN
AL-SAMEERR MAJU

14.

BAE

15.

1 - 4
Design Firm **Steven Lee Design**
5 - 15
Design Firm **FGA**

1.
Client IPvibes
Designer Steven Lee

2.
Client HotSteel
Designer Steven Lee

3.
Client Anneson
Designer Steven Lee

4.
Client autoXpress Lane
Designer Steven Lee

5.
Client Usaha Selatan Logistics Sdn Bhd
Designers FGA Creative Team

6.
Client TTL Distributors Sdn Bhd
Designers FGA Creative Team

7.
Client Shah Maju Holdings Sdn Bhd
Designers FGA Creative Team

8.
Client Stargate Resources
Designer Allen Tan

9.
Client Standard Vision Care Sdn Bhd
Designers FGA Creative Team

10.
Client TCL Plastic Industries Sdn Bhd
Designers FGA Creative Team

11.
Client Shah Maju Holdings Sdn Bhd
Designers FGA Creative Team

12.
Client Lingkaran Unik
 Development Sdn Bhd
Designer Allen Tan

13.
Client Plano-Comp Sdn Bhd
Designer Allen Tan

14.
Client Restoran Al-Sameerr Maju
Designers FGA Creative Team

15.
Client BAE International Inc. Sdn Bhd
Designers FGA Creative Team

PROMOTIONAL TRADESHOW MATERIALS:

- The examples at the right demonstrate several approved executions of the Promotional template in vertical and horizontal applications. Be sure to mix and match the Figure Photography supplied in the Photography Library and NOT focus on a single visual per promotion. The Photography Library was created to reinforce the brand and is not product or Category-specific.

- When creating banners, posters, or any other large format pieces for special events and tradeshows, you may flood with the medium color of the Color Banding System for general corporate. You may also use a Service Category color. Remember that it is NOT necessary to flood the live area with a color all the time, Novell has ownership in large, bold fields of white.

PROMOTIONAL VERTICAL BANNERS

PROMOTIONAL HORIZONTAL BANNERS

PROMOTIONAL FLAGS*

Novell

Novell Branding Guidelines

Design Firm **Hornall Anderson Design Works, Inc.**
Client *Novell, Inc.*
Designers Larry Anderson, Jack Anderson, James Tee, Holly Craven, Michael Brugman, Kaye Farmer, Taro Suzuki, Jay Hilburn, Belinda Bowling

MERCHANDISE:

- Using a sparse look to build brand equity is a mandate from Novell Corporate Marketing.

- All Corporate Merchandise should include the Novell Logo, preferably in Novell Red.

- All Corporate T-shirts should ONLY have the Novell Logo on the front of the shirt. Any deviation from this must be approved by Novell Corporate Marketing.

- The N Graphic and Figure Photography should appear on the back of the T-shirt. (You can use any of the images included on the CD.)

- Corporate Hats should have the N Graphic on the front and the Novell Logo on the back. The Logo appears in Novell Red on a white or light colored hat or white on a red hat.

T-SHIRT

HAT

MOUSEPAD

BUTTON

NAMETAG

- All Corporate Mousepads should be red with a white Novell Logo and the N Graphic and Figure Photography. (You can use any of the images included on the CD)

- For the Corporate Button, the Novell Logo should be set in Novell Red on a white field and sit on a red field that includes the N Graphic and Figure Photography. (You can use any of the images included on the CD.)

- The Corporate Name Tag should follow the Corporate Materials grid. Divide it into 16 equal parts width by height. Fill 9 x 16 parts Novell Red. Fill 16 x 1 part with the Color Banding System. Add the Novell Logo to the white field. Add the Information Matrix and "name" text.

Novell

- The N Graphic and Figure Photography is a combination of the Novell Logo "N" with Photography.

- The N Graphic and Figure Photography always appear in conjunction with the Novell Logo.

- There is an established relationship between the N Graphic and the Figure Photography. DO NOT modify the established spatial relationship.

- These images were created to be used generously. No one image represents a specific Service Category or product. Use all images within the library, and mix and match as much as possible.

- The N Graphic and Figure Photography shown in its entirety is referred to as a Stand-alone Graphic.

- Stand-alone Graphics are used on all Corporate materials.

- A Supergraphic is an enlarged, close crop of the Figure Photography. The N Graphic may be removed from its locked position and placed in general proximity of the figure.

- Supergraphics are used for Promotional materials only.

Novell.

Novell Logo

N Graphic

Figure Photography

N Graphic

Stand-alone Graphic

Figure Photography

ON WHITE BACKGROUND

ON NOVELL RED

ON LIGHT BACKGROUND

ON DARK COLORS

STAND-ALONE GRAPHIC

SUPERGRAPHIC

ONE COLOR ("N" IS 30% SCREEN OF BLACK)

ON COLOR BANDING SYSTEM

COLOR USAGE:

- The Figure Photography always appears as black on a white background OR black on one of the Novell Colors.

- The N Graphic is always Novell Red on a white background OR white on a colored background.

- If only one color is available, the N graphic prints 30% screen of black on a white background. DO NOT place the Figure Photography on a black background.

- For Promotional materials, the Figure Photography can overlap the Color Banding System.

- The images were created to be used as they are. Do NOT manipulate or distort the images found in the Figure Photography Library.

- Figure Photography is always used in conjunction with the N Graphic— never without.

NOTE: The complete directory of the Figure Photography can be found in the Reference section of these Guidelines. Figure Photography images are provided on the Branding Guidelines CDs as 1) high resolution Photoshop tiff files, 2) Illustrator eps files with the N Graphic and 3) as a combined lock-up saved as a 4-color process tiff file. A "How To" Photoshop file has been included to help guide in adding back-ground colors to the Figure Photography.

Novell

All packaging products
are accompanied by
an assortment of
standardized pieces.
Typical in-box components
include registration cards,
reference guides and
license agreements.

Product packaging is
always developed in
concert with Novell
Corporate Marketing
Communication and a
Product Operations
Manager.

PRODUCT BOX

CD LABELS

UPGRADE BOX

CD ENVELOPES

DOCUMENTATION

Product CD Beta CD Evaluation CD

Novell

(continued)
Design Firm **Hornall Anderson Design Works**
Client *Novell, Inc.*

1. TAPCO

2.

3.

Love INC
Love In the Name of Christ

4.

5.

6. **waymar**

7.

1 - 7
Design Firm **Armstrong Graphics**
1.
 Client *Tapco*
 Designer R. Bruce Armstrong
2.
 Client *Digineer*
 Designer R. Bruce Armstrong
3.
 Client *John Danicic*
 Designer R. Bruce Armstrong
4.
 Client *Love Inc.*
 Designer R. Bruce Armstrong
5.
 Client *Edina Five-O Florist*
 Designer R. Bruce Armstrong

6.
 Client *Waymar Restaurant Furniture*
 Designer R. Bruce Armstrong
7.
 Client *Armstrong Graphics*
 Designer R. Bruce Armstrong
(opposite)
 Client *Malaysian Institute of Baking*
 Design Firm **FGA**
 Designers FGA Creative Team

MALAYSIAN INSTITUTE OF BAKING

1.

2.

soNOTED

3.

ORION ADVERTISING

4.

re | salzman designs

5.

6.

7.

TJW VENTURES

substance

151

8.

318

10.

APEX

9.

11.

MiND INVENTIONS

12.

d7cg

13.

ıl|||ıl alphainsight

14.

LITECAST

15.

WASHINGTON

JEWISH

WOMEN'S

PROJECT

1.

2.

MULTIPLY

3.

4.

SLOVENSKO PRAVO
IN GOSPODARSTVO
OB VSTOPU SLOVENIJE V
EVROPSKO UNIJO

5.

JACKSON
P L A Z A

6.

7. MERIDIAN

1, 2
Design Firm **substance 151**
3
Design Firm **Armstrong Graphics**
4, 5
Design Firm **KROG, Ljubljana**
6, 7
Design Firm **Sky Design**
1.
 Client *Washington Jewish*
 Women's Project
 Designers Ida Cheinman, Rick Salzman
2.
 Client *hrAdmin*
 Designers Ida Cheinman, Rick Salzman
3.
 Client *Multiply Communications*
 Designer R. Bruce Armstrong

4.
 Client *Mesarstvo Mlinaric, Lesce*
 Designer Edi Berk
5.
 Client *Pravna fakulteta. Ljubljana*
 Designer Edi Berk
6.
 Client *Gateway Management*
 Designers Celie Goforth, Carrie Brown
7.
 Client *Holder Properties*
 Designers W. Todd Wright, Carrie Brown,
 Matt Worsham
(opposite)
 Client *Maju Avenue*
 Design Firm **FGA**
 Designers FGA Creative Team

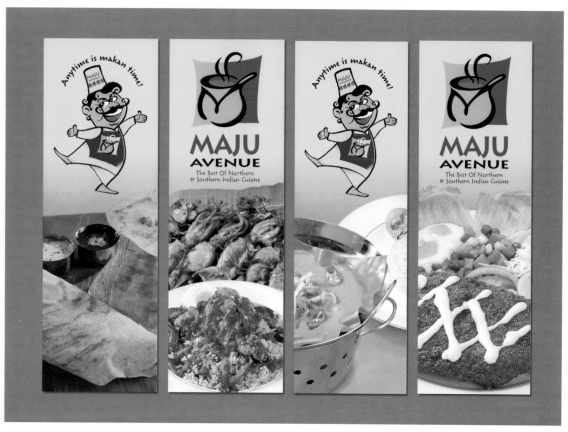

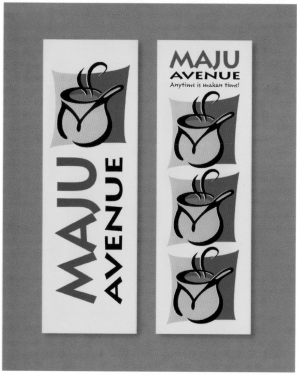

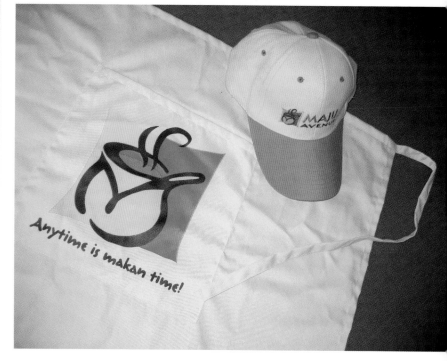

OneBolt

Design Firm **Longwater & Co., Inc.**
Client *One Bolt, Inc.*
Designers Kathryn Strozier,
 Elaine Longwater,
 Anastasia Kontos

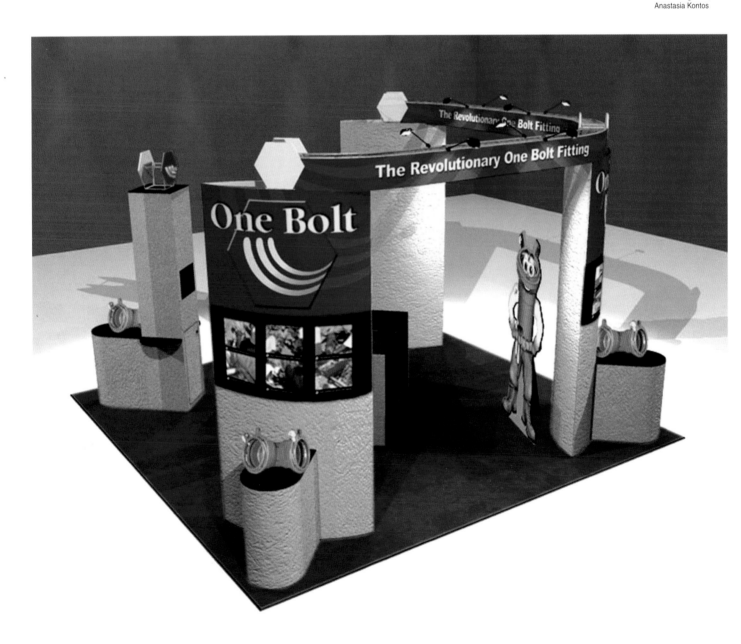

One Bolt

One Bolt, Inc.

One Bolt

One Bolt, Inc.

1.

2.

3.

4.

5.

6.

7.

8.

waterpik™

9.

amœba

10.

amœba

11.

amœba

12.

amœba

13.

amœba

14.

amœba

15.

1 - 9
Design Firm **Source/Inc.**
10 - 15
Design Firm **Bright Strategic Design**
1.
Client *Valeo, Inc.*
Designers Susan Hartline, Sarrah Trembley,
 Bernie Dolph, Mike Nicholson
2.
Client *World Kitchen Inc.*
Designers Sabrina Chan, Adrienne Nole,
 Mike Nicholson
3.
Client *Videojet Technologies*
Designers Scott Burns, Mike Nicholson
4.
Client *Haggerty Enterprises*
Designers Sabrina Chan, Adrienne Nole,
 Mike Nicholson
5.
Client *Chatlem, Inc.*
Designers Mike Nicholson, Bernie Dolph

6.
Client *The Burnes Group*
Designers Adrienne Nole, Mike Nicholson
7.
Client *Gold Eagle Co.*
Designers Scott Burns, Mike Nicholson
8.
Client *Kraft Foods Inc.*
Designers Scott Burns, Adam Ferguson,
 Mike Nicholson, Michael Bast
9.
Client *Waterpik Technologies*
Designers Sabrina Chan, Adrienne Nole,
 Mike Nicholson
10 - 15.
Client *Amoeba*
Designers Keith Bright, Glenn Sakamoto

1.

2.

3.

Doctor Goodwell

4.

5.

6.

7.

8.

9.

TRUE NORTH
FEDERAL CREDIT UNION

10.

11.

TĒLA

12.

 SOUND HEART

13.

SUN VALLEY SUMMER
Symphony

14.

The Yottabyte NetStorage™ Company

15.

1 - 15		
Design Firm	**Phinney/Bischoff Design House**	
1.		
	Client	*Adaptis*
	Designer	Brian Buckner
2.		
	Client	*Power Engineers, Inc.*
	Designer	Cody Rasmussen
3.		
	Client	*Nesting Bird*
	Designer	Dean Hart
4.		
	Client	*Doctor Goodwell*
	Designers	Dean Hart, Lorie Ransom
5.		
	Client	*Children's Hospital Seattle*
	Designer	Cody Rasmussen
6.		
	Client	*Children's Hospital Seattle*
	Designer	Lorie Ransom
7.		
	Client	*Captaris*
	Designer	Dean Hart

8.		
	Client	*Verity Credit Union*
	Designer	Cody Rasmussen
9.		
	Client	*University of Washington*
	Designer	Lorie Ransom
10.		
	Client	*True North Federal Credit Union*
	Designer	Lorie Ransom
11.		
	Client	*Torrefazione Italia*
	Designers	Dean Hart, Brian Buckner
12.		
	Client	*Tela*
	Designer	Lorie Ransom
13.		
	Client	*Sound Heart*
	Designer	Dean Hart
14.		
	Client	*Sun Valley Summer Symphony*
	Designer	Dean Hart
15.		
	Client	*Yotta Yotta*
	Designer	Cody Rasmussen

Design Firm **Sky Design**
Client *The Forum*
Designers W. Todd Vaught,
 Celie Goforth

1.

2. MEADOWS, ICHTER & BOWERS
ATTORNEYS AT LAW

3.

HALO

4.

*green*HOUSE

5.

6.

PENTERRA PLAZA

7.

1 - 4
Design Firm **Sky Design**
5 - 7
Design Firm **Noble Erickson Inc.**
1.
 Client *Georgia Medical Care Foundation*
 Designers Celie Goforth, W. Todd Vaught,
 Carrie Brown
2.
 Client *Meadows, Ichter & Bowers*
 Designers W. Todd Vaught, Matt Worsham
3.
 Client *Pinewoods*
 Designers W. Todd Vaught,
 Carrie Brown
4.
 Client *Halo*
 Designers W. Todd Vaught,
 Thom Williams

5.
 Client *Zeppelin Development*
 Designer Jackie Noble
6.
 Client *The Rose Foundation*
 Designer Robin Ridley
7.
 Client *Simpson Housing*
 Designers Steven Erickson, Jackie Noble,
 Robin Ridley
(opposite)
 Client *DataPeer, Inc.*
 Design Firm **Design Source East**
 Designer Mark Lo Bello

power^2sync

Powered by DataPeer, Inc.

power^2share

Powered by DataPeer, Inc.

power^2search

Powered by DataPeer, Inc.

power^2network

Powered by DataPeer, Inc.

power^2store

Powered by DataPeer, Inc.

power^2host

Powered by DataPeer, Inc.

power^2protect

Powered by DataPeer, Inc.

power^2govern

Powered by DataPeer, Inc.

power^2educate

Powered by DataPeer, Inc.

power^2profit

Powered by DataPeer, Inc.

Laszlo Moholy-Nagy
Photo: Laszlo Moholy-Nagy Foundation

Modern Architecture and Design group invites you to join

Why we're here — why you should join

A diverse group of architects, designers, collectors, dealers, curators and enthusiasts have organized in response to a need for a forum in which to gather information...
creative 20...
migration...
continued...
its influenc...

Chicago B...
events rela...
graphic de...
and desig...

Modernism...
will play a...

A non-profit organization celebrating and promoting awareness of 20th Century modern architecture and design. For detailed information check out our web site:

www.chicagobauhausbeyond.org
or call: 312.371.0986

Founding m...
writer and c...
known colle...
in libraries,...
clients, and...
past. The G...
but not to th...

Join Ci...

Modern Architecture and Design group invites you to join

A non-profit organization celebrating and promoting awareness of 20th Century modern architecture and design. For detailed information check out our web site:

www.chicagobauhausbeyond.org
or call: 312.371.0986

Events and Future Plans

Our next event: Sunday, April 18, 2004 / 1-3 pm
will be a guided tour of the Bauhaus Apprenticeship Institute 1757 North Kimball Avenue, Chicago, Illinois. The BAI is a non-profit organization dedicated to rigorous, practical and professional education in American art and craft furniture.

"Show and Tell" — For those who wish to participate, bring one of your favorite small Modernist objects: pottery, glass, sculpture, photos, graphics, jewelry, artwork or whatever excites you. Share your stories about these pieces.

This event is **free** for members and a $5.00 donation for guests. Please RSVP to Joe Kunkel by email: joe@jetsetmodern.com or call Joan Gand: 847.445.6008

Chicago Bauhaus and Beyond invites you to join us for tours, seminars, lectures and special events exploring the rich architectural and design heritage of Chicago and the people who helped create it. Modernism is alive and active in the area and creating a new legacy in which we will play a part.

Join the exciting new modernism design group in Chicago

Design Firm **Allen Porter Design**
Client *Chicago Bauhaus and Beyond*
Designer Allen Porter

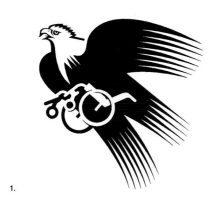

1.

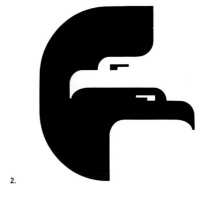

2.

3.

DOUBLE EAGLE
R E S T A U R A N T

4.

5.

W ———————————————————— E

WESTERN EXPOSURE

6.

Polo Ridge
F A R M S

7.

8.

POINTE
OF

VIEW

9.

GAMEKEEPER'S

GRILLE

10.

11.

12.

13.

14. **ROCKY MOUNTAIN BAIL BONDS**

15. WITHERBEE WILDERNESS CAMP

1 - 15
Design Firm **The Weller Institute**
for the Cure of Design, Inc.

1.
Client *Park City Handicapped*
 Sports Association
Designer Don Weller

2.
Client *Double Eagle Lodge at Deer Valley*
Designer Don Weller

3.
Client *Alpha Graphix*
Designer Don Weller

4.
Client *Double Eagle Restaurant*
Designer Don Weller

5.
Client *The Design Conference That Just*
 Happens To Be In Park City
Designer Don Weller

6.
Client *Western Exposure*
Designer Don Weller

7.
Client *Polo Ridge Farms*
Designer Don Weller

8.
Client *The Weller Institute*
Designer Don Weller

9.
Client *Pointe of View*
Designer Don Weller

10.
Client *Gamekeeper's Grille Restaurant*
Designer Don Weller

11.
Client *Todd Ware Massage*
Designer Don Weller

12.
Client *Plyfibres, Inc.*
Designer Don Weller

13.
Client *Takota Traders*
Designer Don Weller

14.
Client *Rocky Mountain Bail Bonds*
Designer Don Weller

15.
Client *Witherbee Wilderness Camp*
Designer Don Weller

INDIAN
RIDGE
GOLF CLUB

1.

2.

3.

4.

5.

6.

7.

Client *Animal Planet*
Design Firm **Animal Planet**

Patterns

The **most striking**

artistic patterns

	DALMATIAN		
	TIGER		
	CHEETAH		
	GIRAFFE		

Silhouetting

Do it right—or there will be consequences. Trust me!

To focus attention on the animal rather than its habitat, remove the backgrounds from photographs whenever practical.

Use sharp, crisp photographs that silhouette cleanly.

Before:
The background distracts from the star of the show.

After:
By removing the background, attention is focused on the animal.

IMAGE DON'TS

Don't use complicated images. They should be well defined and easy to silhouette. If you must include a background, keep it simple.

Don't use images that look posed or premeditated. Animal Planet images should be full of character and expression.

Don't use images of expressionless animals. It's difficult, for example, to get a good sense of the personality of a shark.

Don't use aggressive or ferocious images.

3.5

Mix and match colors and patterns to produce interesting combinations beyond what is found in nature. Be sure to use stylized colors to avoid anything looking like actual fur.

are inspired by animals

BIRD

When text is positioned on top of patterns, use subtle tonal combinations so that text is readable.

COW

REPTILE

ZEBRA

3.9

(continued)
Client *Animal Planet*
Design Firm **Animal Planet**

ANIMAL PLANET Animusings™

Thought balloons containing Animusings™ should be drawn to resemble soft, puffy clouds with a trail of three bubbles, descending in size, leading to the animal.

And remember, these are thought balloons...animals don't speak.

The use of these thought balloons helps humans to better understand OUR way of thinking.

ANIMUSINGS™

Samples of Animusings artwork can be downloaded from the Virtual Library.

3.11

(opposite)
Client *TrueFACES*
Design Firm **TrueFACES Creation**
Designer Allen Tan

1.

2.

3.

4.

5.

6.

7.

8.

342

9.

10.

11.

12.

AMERICAN

MUSEUM OF QUILTS

& TEXTILES

13.

COSMOPOLITAN

G R I L L

14.

Media-
Network

15.

1, 2, 4 - 8
 Design Firm **Back Yard Designs**
3
 Design Firm **Margo Chase Design**
9 - 14
 Design Firm **Tharp Did It**
15
 Design Firm **Bruce Yelaska Design**
1.
 Client *Atlantic Records*
 Designer Lorna Stovall
2.
 Client *Scream, Inc.*
 Designer Lorna Stovall
3.
 Client *Hot Mustard Records/MCA*
 Designer Lorna Stovall
4.
 Client *Eric Lamers*
 Designer Lorna Stovall
5, 6.
 Client *Zenobia Agency*
 Designer Lorna Stovall
7.
 Client *40 Acres & A Mile*
 Designer Lorna Stovall

8.
 Client *Trish & Martin Hurst*
 Designer Lorna Stovall
9.
 Client *Bayshore Press*
 Designers Rick Tharp, Jan Heer
10.
 Client *The Dashboard Company*
 Designers Rick Tharp, Nicole Coleman
11.
 Client *TrukkE Winter Sports Boots*
 Designers Rick Tharp, Susan Jaekel
12.
 Client *Harmony Foods*
 Designers Rick Tharp, Nicole Coleman
13.
 Client *American Museum of*
 Quilts & Textiles
 Designers Rick Tharp, Gina Kim-Mageras
14.
 Client *Cosmopolitan Grill*
 Designers Rick Tharp, Susan Craft
15.
 Client *Media-Network*
 Designer Bruce Yelaska

ACCURATE
COMPLIANCE
T E C H N O L O G I E S

1.

NOW
SEE
HERE

2.

MATTEL
MEDIA™

3.

PACIFIC MOOD

BY WILLIAM HO

4.

[M A S T E R M I N D]
T E C H N O L O G I E S

5.

GreenRiver
C O M M U N I T Y C O L L E G E

6.

RUMOURS
D I S C O T H E Q U E

7.

1
Design Firm **GOLD & Associates**
2
Design Firm **Fairly Painless Advertising**
3
Design Firm **B.D. Fox & Friends, Advertising**
4
Design Firm **William Ho Design Associates Ltd.**
5
Design Firm **Lomangino Studio Inc.**
6, 7
Design Firm **Hansen Design Company**
1.
Client *Accurate Compliance Technologies*
Designer Keith Gold
2.
Client *Miller SQA*
Designers Steve Frykholm,
 Brian Hauch

3.
Client *Mattel*
Designer Garrett Burke
4.
Client *Pacific Mood*
Designer William C.K. Ho
5.
Client *Mastermind Technologies*
Designer Arthur Hsu
6.
Client *Green River
 Community College*
Designers Pat Hansen, Jesse Doquilo
7.
Client *Rumours Discotheque*
Designers Pat Hansen, Sheila Schimpf
(opposite)
Client *jstar Brands*
Design Firm **Cahan & Associates**
Designers Michael Braley, Bill Cahan,
 Todd Simmons

1.

2.

3.

4.

5.

6.

7.

8.

9.

STRATEGIC CONCEPTS

10. INCORPORATED

TPsyTrust

11.

12.

IRS

SERVICE TEAM

13.

14.

15.

1 - 3, 5
Design Firm **Dart Design**
4
Design Firm **Kendrew Group**
6 - 15
Design Firm **Fuller Designs, Inc.**

1.
Client — Arena Communications
Designer — David Anderson
2.
Client — Post Road Chiropractic
Designer — David Anderson
3.
Client — Success Printing
Designer — David Anderson
4.
Client — HBO
Designer — David Anderson-Dart Design
5.
Client — Dart Design
Designer — David Anderson
6.
Client — Future Business Leaders of America
Designer — Doug Fuller

7.
Client — Sharp Building Corp.
Designer — Doug Fuller
8.
Client — McDonald Management Solutions
Designer — Doug Fuller
9.
Client — Integrated Healthcare
 Arlington Hospital
Designer — Doug Fuller
10.
Client — Strategic Concepts, Inc.
Designer — Doug Fuller
11.
Client — PsyTrust, LLC
Designer — Doug Fuller
12.
Client — Florida Entech Corporation
Designer — Doug Fuller
13.
Client — Price Waterhouse
Designer — Doug Fuller
14.
Client — Regis Lefebure Photography
Designers — Doug Fuller, Aaron Taylor
15.
Client — Active Adventures
Designer — Doug Fuller

1.

2.

3.

4.

5.

6.

5.

7.

1, 2
Design Firm **Pedersen Gesk**
3, 4
Design Firm **Jefrey Gunion**
 Illustration & Design
5, 6
Design Firm **Grizzell & Co.**
7
Design Firm **IE Design + Communications**
1.
Client *Lincoln Brewing*
Designers Rony Zibara, Roger Remaley
2.
Client *White Lily*
Designers Rony Zibara, Andrea Williams
3.
Client *APEX Adventures*
Designer Jefrey Gunion

4.
Client *Baseline Music & Video*
Designer Jefrey Gunion
5.
Client *Richfield Properties Inc.*
Designer John H. Grizzell
6.
Client *HSES*
Designer John H. Grizzell
7.
Client *Wilcoxen Design*
Designers Marcie Carson, Cya Nelson
(opposite)
Client *Golden Triangle Association*
Design Firm **Noble Erickson Inc.**
Designers Jackie Noble,
 Lisa Scheideler

348

GTA

GOLDEN TRIANGLE

Are **you** in the ▲?

HEY ARNOLD! LOGO

Show Logos

Standard Full Color Logo

HEY ARNOLD!™

black	PMS 122c
C= 40 M= 40 Y= 40 K= 100	C= 0 M= 15 Y= 100 K= 0

Black & White Logo

HEY ARNOLD!™

black	white
C= 40 M= 40 Y= 40 K= 100	

Full Color Logo on Dark Background

HEY ARNOLD!™

PMS 1795c	PMS 122c
C= 10 M= 90 Y=100 K= 0	C= 0 M= 15 Y= 100 K= 0

Full Color Packaging Logo with Nickelodeon Logo

NICKELODEON HEY ARNOLD!™

PMS 021c	black	PMS 122c
	C= 40 M= 40 Y= 40 K= 100	C= 0 M= 15 Y= 100 K= 0

©

Design Firm **Nickelodeon**
Client *Nickelodeon*

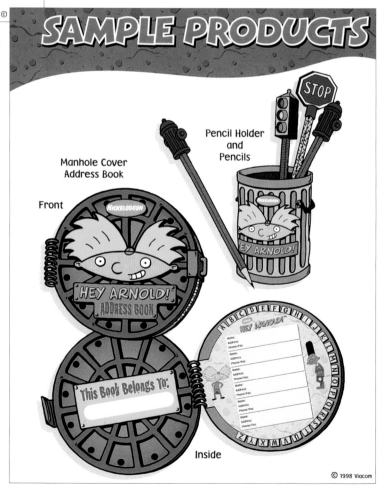

SAMPLE PRODUCTS

Manhole Cover
Address Book

Front

Pencil Holder
and
Pencils

This Book Belongs To:

Inside

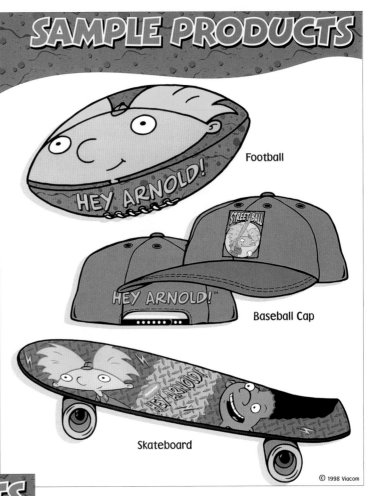

Football

Baseball Cap

Skateboard

© 1998 Viacom

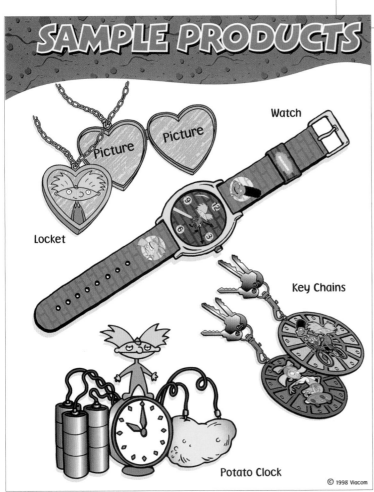

Watch

Picture Picture

Locket

Key Chains

Potato Clock

© 1998 Viacom

351

(continued)
Design Firm **Nickelodeon**
Client *Nickelodeon*

Design Firm **FGA**
Client *Ecotint (M) Sdn Bhd*
Designers FGA Creative Team

SMART

SOLUTION

TO

AUTOMOTIVE

VENTILATION

REDUCES CABIN TEMPERATURE BY 10°C OR MORE

GETS YOUR AIR-COND TO OPTIMUM TEMPERATURE 10 TIMES QUICKER

REDUCES HEAT AND HUMIDITY AT VEHICLE START-UP

REDUCES INTERIOR DAMAGE CAUSED BY HEAT

INTELLIGENT BATTERY "WATCHDOG"

KEEPS VEHICLE INTERIOR SMELLING FRESH (BY FRESH AIR CIRCULATION)

1 YEAR MANUFACTURER WARRANTY

EASY INSTALLATION WITH NO DRILLING REQUIRED

1.

Creative Finds For Creative Minds
University Art

2.

DecisionMaker.

3.

4.

THORENFELDT CONSTRUCTION, INC.

5.

OUTSOURCE, INC.
Fulfillment and Distribution Services

6.

CARE
A PROGRAM ESPECIALLY FOR WOMEN

7.

8.

9.

10.

11.

PENNSYLVANIA
EARLY STAGE PARTNERS

12.

INTERNATIONAL
DESIGN
PARTNERSHIP **idp** sm

13.

14.

PLATINUM

15.

1 - 7			**7.**		
Design Firm	**Imtech Communications**		Client	CARE (Cancer Awareness Research & Education)	
8 - 12			Designer	Robert Keng	
Design Firm	**NDW Communications**		**8.**		
13 - 15			Client	Barclay White, Inc.	
Design Firm	**Lipson, Alport, Glass & Associates**		Designer	Bill Healey	
1.			**9.**		
Client	BART (SF Bay Area Rapid Transit)		Client	Dudnyk & Volk Advertising	
Designer	Robert Keng		Designer	Bill Healey	
2.			**10.**		
Client	University Art		Client	210 Productions, Inc.	
Designer	Robert Keng		Designer	Bill Healey	
3.			**11.**		
Client	Ma Labs		Client	Acis, Inc.	
Designer	Robert Keng		Designer	Bill Healey	
4.			**12.**		
Client	ProActive CARE		Client	PA Early Stage Partners	
Designer	Robert Keng		Designer	Tom Brill	
5.			**13.**		
Client	Thorenfeldt Construction, Inc.		Client	International Design Partnership	
Designer	Robert Keng		Designers	Lipson, Alport, Glass, & Associates	
6.			**14.**		
Client	Outsource, Inc.		Client	Schrader Bridgeport	
Designer	Robert Keng		Designer	Keith Shure	
			15.		
			Client	Platinum Home Mortgage	
			Designer	Katherine Holderfled	

1.

2.

3.

4.

5.

6.

7.

1, 2
Design Firm **Rousso+Associates, Inc.**
3, 4
Design Firm **Torrisi Design Associates, Inc.**
5 - 7
Design Firm **Minoru Morita Graphic Design**
1.
Client *The Melamine Corporation*
Designer Steven B. Rousso
2.
Client *Taylor Mathis*
Designer Steven B. Rousso
3.
Client *PCS Connect*
4.
Client *Primary Consulting Services*

5.
Client *Design M*
Designer Minoru Morita
6.
Client *M Studio*
Designer Minoru Morita
7.
Client *Forgerty Family*
Designer Minoru Morita
(opposite)
Client *Retina Consultants of*
 Southwest Florida
Design Firm **Cave**
Designers David Edmundson,
 Matt Cave

ALLIED-DIAMOND
CONSTRUCTION CORP.

1.

ADWELL
COMMUNICATIONS

2.

A U R O R A

3.

TROPICAL LAI

4.

MILL POND
LANDSCAPING

5.

FRENCH Roast

RITUALS • COFFEE

6.

south
american

SELECT

RITUALS • COFFEE

7.

RITUALS

8.

HARBOR

9. BANKS ™

10. **Tecton**Architects│pc

MEDSERV
OF CONNECTICUT, INC.

12.

11.

LANG
PHOTO

13.

14.

15.

1 - 5
Design Firm **Guarino Graphics, Ltd.**
6 - 9
Design Firm **Callahan and Company**
10 - 13
Design Firm **Ritz Henton Design Group**
14, 15
Design Firm **Robert W. Taylor Design, Inc.**
1.
Client *Allied Diamond Construction*
Designer Jan Guarino
2.
Client *Adwell Communications*
Designer Jan Guarino
3.
Client *Aurora Productions*
Designer Jan Guarino
4.
Client *The Three Musketeers*
Designer Jan Guarino

5.
Client *Mill Pond Landscaping*
Designer Jan Guarino
6, 7.
Client *Rituals Coffee*
Designers Paula Sloane, Jonathan Carlson
8, 9.
Client *JP Foodservice*
Designer Paula Sloane
10.
Client *Tecton Architects, P.C.*
11.
Client *Total Healthcare Solutions, Inc.*
12.
Client *MedServ of Connecticut, Inc.*
13.
Client *Lang Photography*
14.
Client *Valleylab, Inc.*
Designer Robert W. Taylor
15.
Client *Colorado Sports Hall of Fame*
Designers Robert W. Taylor,
 Gwyn VanderVorste

1.

2. **L M I**

3.

4.

5.

6.

7.

1	
Design Firm	**Robert W. Taylor Design, Inc.**
2 - 4	
Design Firm	**Zunda Design Group**
5 - 7	
Design Firm	**Design Objectives Pte Ltd**

1.
Client — *Center for International Trade Development*
Designer — Robert W. Taylor

2.
Client — *Liebhardt Mills, Inc.*
Designer — Charles Zunda

3.
Client — *USA Detergents*
Designer — Todd Nickel

4.
Client — *Zunda Design Group*
Designers — Todd Nickel, Charles Zunda

5.
Client — *Singapore Economic Development Board*
Designer — Ronnie S C Tan

6.
Client — *Temasia Health Pte Ltd*
Designer — Ronnie S C Tan

7.
Client — *Lee Hwa Jewellery Pte Ltd*
Designer — Ronnie S C Tan

(opposite)
Client — *Southern Specialties*
Design Firm — **Cave**
Designers — David Edmundson, Matt Cave

our new look

Our new identity stands for the essence of our company – it is a graphic representation of our core values. In a sense, our identity is a promise to customers, investors, competitors and the rest of our worldwide audience. It pledges that we will strive to act and communicate in an energetic, forthright and forward-thinking way in everything we do. As we show this new face to the world, we send a clear message: BP is leading the changes taking place in our industry. Our striking new look reflects the bold steps we're taking in every area, from technology to exploration to environmental protection. And this is just the beginning.

Design Firm **Landor Associates**
Client *BP Amoco*
Designers Margaret Youngblood,
 Nancy Hoefig,
 Courtney Reeser,
 Peter Harleman,
 David Zapata,
 Brad Scott,
 Cynthia Murnane,
 Todd True,
 Frank Mueller,
 Michele Berry,
 Cameron Imani,
 Ivan Thelin,
 Ladd Woodland,
 Maria Wenzel,
 Jane Bailey,
 Susan Manning,
 Wendy Gold,
 Greg Barnell,
 Stephen Lapaz,
 Bryan Vincent,
 Russell DeHaven

(continued)
Design Firm **Landor Associates**
Client *BP Amoco*

1.

2.

3.

4.

5.

6. LITESOM CORPORATION

7.

1 - 5
Design Firm **Tieken Design
& Creative Services**

6, 7
Design Firm **The Corporate Identity People**

1.
Client *Graham Associated Advertising*
Designers Fred E. Tieken,
 Rik Boberg

2.
Client *Graham Associated Advertising*
Designers Fred E. Tieken,
 Sarah Spencer

3.
Client *GES Exposition Services*
Designers Fred E. Tieken

4.
Client *GES Exposition Services*
Designers Fred E. Tieken,
 Sarah Spencer

5.
Client *PhotosOnCD*
Designers Fred E. Tieken

6.
Client *Litesom Corporation*
Designer Joseph Finisdore

7.
Client *SCT-Systems
 & Computer Technology*
Designer Joseph Finisdore
(opposite)
Client *Palermo's*
Design Firm **Design North, Inc.**

Design Firm **Be Design**
Client *Frontier Natural Products*
Designers Eric Read,
 Suzanne Hadden,
 Monica Vallejos,
 Will Burke

(continued)
Design Firm **Be Design**
Client *Frontier Natural Products*

1.

YANGTZE COUNCIL

2.

G
R
A
N
G
E

GRANGE 70 G 00

3.

4.

CALIFORNIA

STAR OAK

PRIVATE RESERVE

alcohol 12.5% by volume

2001 CABERNET SAUVIGNON

5.

 SuzyPress agency

6.

7.

1
Design Firm **Design Objectives Pte Ltd**
2 - 4
Design Firm **Kinggraphic**
5
Design Firm **Will Winston Design**
6
Design Firm **Mikael T. Zielinski**
7
Design Firm **Designs On You!**

1.
Client *Temasia Health Pte Ltd*
Designer Ronnie S.C, Tan
2.
Client *Shanghai-Hong Kong Council for the Promotion & Development of Yangtze*
Designer Hon Bing-wah
3.
Client *Sino Group*
Designer Hon Bing-wah
4.
Client *Far East Organization*
Designer Hon Bing-wah

5.
Client *Prince Michel/Kroger*
Designer Will Casserly
6.
Client *SuzyPress Agency*
Designer Mikael T. Zielinski
7.
Client *Sisler-Maggard Engineering, PLLC*
Designers Suzanna Stephens, Anthony B. Stephens

(opposite)
Client *Pekoe Siphouse*
Design Firm **Be Design**
Designers Monica Schlaug, Will Burke

pekoe

Design Firm **FutureBrand**
Client *UPS*
Designers Claude Salzberger,
 Sven Seger,
 Diego Kolsky,
 Michael Thibodeau,
 Alan Campbell,
 Marco Acevedo,
 Michael Matthews,
 Marie Schabenbeck,
 Mike Sheehan,
 Phil Rojas,
 Tom Li

Worldwide Services

TM

(continued)
Design Firm **FutureBrand**
Client *UPS*

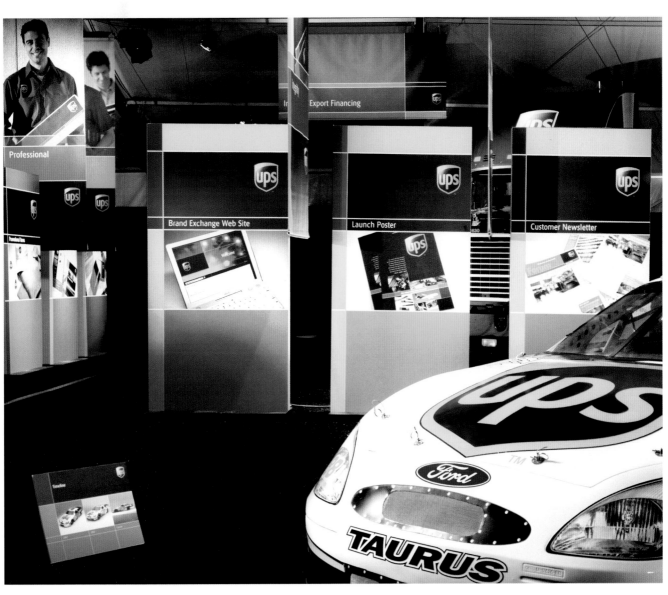

1.

contada™

2.

doGGone crazy!™

3.

nexGen
UTILITIES

4.

DATAHORSE
DGC
GROUP of COMPANIES

5.

WR&CO
WaterReport&Consulting

6.

Innovacht
CUSTOM TECHNOLOGIES

7.

H·Q
SWISS MADE

8.

9.

CAMERA DI COMMERCIO
INDUSTRIA ARTIGIANATO AGRICOLTURA
DI VICENZA

10.

eyeonics™
evolving vision

11.

ADVUEŪ
YOUR WORLD, YOUR VIEW

12.

crystalens™
see all the possibilities

13.

14.

15.

BLOCK PLUS (M) SDN. BHD.

1.

ijuˡinštitutzajavnoupravo

2.

inštitutzaprimerjalnopravo

3.

TOŠ

4.

MARTIN KRPAN Z VRHA

5.

saðno

6.

V·I·V
VitamImpendere VERO

7.

1
 Design Firm **FIXGO ADVERTISING
 (M) SDN BHD**
2 - 7
 Design Firm **KROG**
1.
 Client *Block Plus (M) Sdn Bhd*
 Designers FGA Creative Team
2.
 Client *Institut za javno upravo, Ljubljana*
 Designer Edi Berk
3.
 Client *Institut za primerjalno
 pravo, Ljubljana*
 Designer Edi Berk
4.
 Client *Peter Tos, Ljubljana*
 Designer Edi Berk

5.
 Client *Presernova druzba, Ljubljana*
 Designer Edi Berk
6.
 Client *Zlati gric, Slovenske Konjice*
 Designer Edi Berk
7.
 Client *Pravna fakulteta, Ljubljana*
 Designer Edi Berk
(**opposite**)
 Client *A&P Canada*
 Design Firm **LogosBrands**
 Designers Gabriella Sousa,
 Sunny Chan

MASTER CHOICE

MC ™

FINE BRITISH

CORNISH

Savoury beef and vegetab

CANADA
185

MASTER CHOICE

MC ™

FINE BRITISH TRADITION

MELTON MOWBRAY PIE

Mildly seasoned pork pie with crisp pastry – gelatine filled in the traditional style!

CANADA
460

| KEEP FROZEN | 400 g |
| SUGGESTED SERVING | |

OHANA FARM

1.

2.

ARTSOPOLIS™

3.

James
Phillip
Wright **Architects**

4.

CMG FOUNDATIONS

5.

photo TLC™

6.

AAKU

7.

AAKU

8.

382

9.

10.

11.

12.

S K Y L A R
+
H A L E Y

13.

14.

15.

1.

3. **North American Shippers Association, Inc.**

5.

2.

4.

6.

7.

1 - 7

Design Firm **Longwater & Co., Inc.**

1.
Client — *Savannah Onstage*
Designers — Kathryn Strozier, Elaine Longwater, Anastasia Kontos

2.
Client — *Asian Automotive*
Designers — Kathryn Strozier, Elaine Longwater, Anastasia Kontos

3.
Client — *North American Shippers Association*
Designers — Kathryn Strozier, Elaine Longwater, Anastasia Kontos

4.
Client — *Brad Durham, DMD*
Designers — Kathryn Strozier, Elaine Longwater, Anastasia Kontos

5.
Client — *Gresham Marine Surveying, Inc.*
Designers — Kathryn Strozier, Elaine Longwater, Anastasia Kontos

6.
Client — *McPherson Manufacturing*
Designers — Kathryn Strozier, Elaine Longwater, Anastasia Kontos

7.
Client — *Yours By Design, LLC*
Designers — Kathryn Strozier, Elaine Longwater, Anastasia Kontos

(opposite)
Client — *Ruffin' It Pet Supplies*
Design Firm **Designs On You!**
Designers — Anthony B. Stephens, Suzanna Stephens,

CODECORRECT

1.

STONE BARNS CENTER
FOR FOOD & AGRICULTURE

2.

RACHEL ASHWELL
SHABBY CHIC
EST 1989

3.

COLOR PRESERVE™

4.

BONK

5.

SENSA

6.

7.

8.

386

9.

10.

11.

12.

13.

14.

15.

aging

1.

line

2.

LBI Unfallforschung

3.

view**point**system

4.

RESOLUTION
L I N E

5.

vogel & NOLL
v e r l a g

6.

Brüd3r

7.

1 - 7
Design Firm **designbuero**
1, 2.
 Client *Dr. Temt Laboratories*
 Designer Thomas Stockhammer
3.
 Client *LBI Unfallforschung*
 Designer Thomas Stockhammer
4.
 Client *view point system*
 Designer Thomas Stockhammer
5.
 Client *Dr. Temt Laboratories*
 Designer Thomas Stockhammer
6, 7.
 Client *DOR Film*
 Designer Thomas Stockhammer

(opposite)
 Client *Cedar Bluff Middle School*
 Talented and Gifted Group
Design Firm **Designs On You!**
Designers Suzanna Stephens,
 Anthony B. Stephens

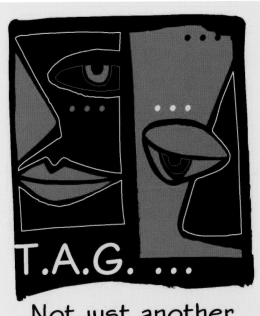

Not just another
pretty face!

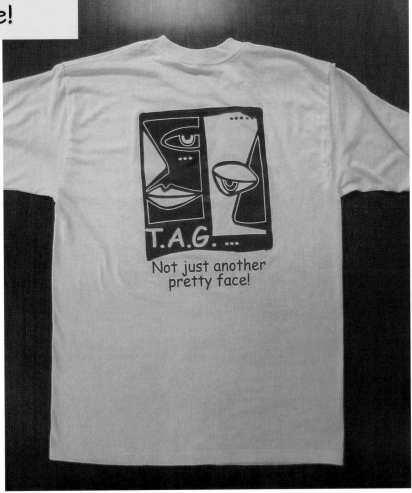

Verizon:
Start-Up Standards

Verizon Logo Key Applications

▶ Detailed specifications for specific key applications of the logo are being developed and are available through the Corporate Identity Manager.

52 V.3.0 (06/23/00)

► Detailed specifications for fleet graphics are being developed and are available through the Corporate Identity Manager.

1.

IL PORTICO

2. RISTORANTE ITALIANO

3.

4. RISTORANTE ITALIANO

5.

6.

7.

1 - 4
Design Firm **Zygo Communications**
5 - 7
Design Firm **66 communication inc.**

1.
 Client *IL Tartufo*
 Designer Scott Laserow
2.
 Client *IL Portico*
 Designer Scott Laserow
3.
 Client *MindBridge*
 Designer Scott Laserow
4.
 Client *TiraMisu*
 Designer Scott Laserow
5.
 Client *Infinity Industries Inc.*
 Designer Chin C. Yang

6.
 Client *Deco Enterprise Co., Ltd.*
 Designer Chin C. Yang
7.
 Client *Delmar International Inc.*
 Designer Chin C. Yang
(opposite)
 Client *CompanyB, Inc.*
 Design Firm **Finished Art, Inc.**
 Designers Donna Johnston, Kannex Fung,
 Barbara Dorn, Luis Fernandez,
 Li-Kim Goh, Mary Jane Hasek,
 Cory Langner, Ake Nimsuwan,
 Larry Peebles, Anne Vongnimitra

CompanyB, Inc.

B-TONE

1.

ELM STREET
RESOURCES, INC.

2.

3.

4.

5.

6.

7.

1
 Design Firm **Designs On You!**
2 - 7
 Design Firm **Design Center**
5 - 7
 Design Firm **Design Objectives Pte Ltd**
1.
 Client *Chapman Printing* and
 Elm Street Resources
 Designers Anthony B. Stephens,
 Suzanna Stephens
2.
 Client *Design Center*
 Designer Eduard Cehovin
3.
 Client *Ulysses Theatre*
 Designer Eduard Cehovin

4.
 Client *Ministry for Ecology*
 Designer Eduard Cehovin
5.
 Client *Yo.Stream.Net*
 Designer Eduard Cehovin
6.
 Client *FYM Cosmetics*
 Designer Eduard Cehovin
7.
 Client *Ad Futura Foundation*
 Designer Eduard Cehovin
(opposite)
 Client *Birds Eye Foods*
 Design Firm **Design North, Inc.**

Index

397

400